IMAGES
of America

AVON

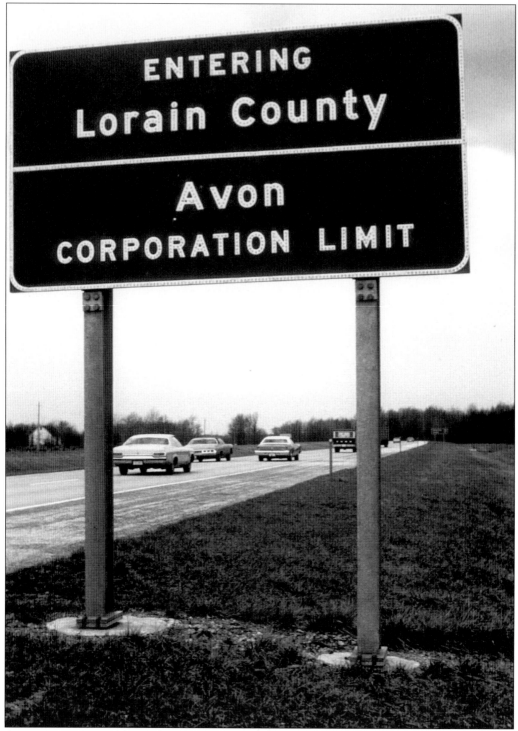

AVON, OHIO. Avon is located in the northeastern part of Lorain County, adjacent to Cuyahoga County and about five miles from Lake Erie.

IMAGES
of America

AVON

Michelle M. Budzinski-Braunscheidel
with the FCDA and the Avon Historical Society

ARCADIA

Published by Arcadia Publishing
Charleston SC, Chicago IL, Portsmouth NH, San Francisco CA

Printed in Great Britain

Library of Congress Catalog Card Number: 2004111302

For all general information contact Arcadia Publishing at:
Telephone 843-853-2070
Fax 843-853-0044
E-mail sales@arcadiapublishing.com
For customer service and orders:
Toll-Free 1-888-313-2665

Visit us on the internet at http://www.arcadiapublishing.com

On the cover: **THE MILLINERY SHOP.** The town's millinery shop was owned by May Weber, who is sitting in front. Lizzie Taft is standing next to the building. May Weber sold schoolbooks and supplies, thread, dollies, calico, and gingham.

CONTENTS

ACKNOWLEDGMENTS

A project such as this involves collaboration and dedication from a number of people. The pictures in this book come primarily from two sources: the Avon Historical Society and area citizens. Many of the images are being published for the first time. Credit is given to the individuals who have donated their pictures.

A very special thank-you goes to my husband, Ed, and my daughter, Nicole, for their enormous patience, support, and encouragement they offered every time I worked on the project. I love them very dearly.

Special thanks go to Michael Vasilof, who laboriously scanned each image using his technical expertise that was so critical to this book. Special thanks to the following French Creek Development Association members: Carol Hartwig, Michael Beck, Lauren Davis, Taylor J. Smith, and Paul and Fran Burik for being dedicated to meeting and working behind the scenes.

Last but not least, the following people have graciously shared pride, heritage, memories, and feelings through their photographs and recollections: Jean Fischer, Jean McKitrick, Debbie Chappo, Dorothy Newport, Joann Albert, Marcia Frank, Steve and Sherry Harris, Mayor James A. Smith, Robert Gates Sr., Robert Gates Jr., Lois Shinko, Karel Pickering, Julie A. Short, Avon Local Schools, Joseph Richvalsky, Karen and Skip Conant, Tom Wearsch, Ann and Richard Bort, Ralph White, Bill Hemminger, Janet Knight, Ron Larson, Lisa Dove from Zeisler-Morgan Properties Ltd., Sherry Stockard, Helen Schatschneider, Donna Freshwater, Alan Nagy, the Littell family, Coletta Holowecky, Avon Jr. Woman's Club, Henkel Consumer Adhesives, and of course the Avon Historical Society; without their support and resources this could not have been possible.

INTRODUCTION

The city of Avon, Ohio, is located in the northeast section of Lorain County near Lake Erie. Following the Revolutionary War of 1776, the 13 original colonies were urged to give up their western territories to provide new land for new states to be formed. Connecticut was a big land holder with the Western Reserve, which stretched from Pennsylvania to the Sandusky Bay and included the land that Avon now sits upon. The land was sold off, and in 1807, Pierpont Edwards purchased the parcel of land that included Avon, then known as Xeuma and later called Troy.

Wilbur Cahoon led some of Avon's first settlers to the area in 1814. The families plotted their homesteads and began a new life here. In 1824, Lorain County was created, and the township name was changed from Troy to Avon. Farming was the way of life for a very long time. Then the trolley line made it possible for people to work in the city and to transport goods to the city market.

Avon entered the 1950s with a bang. The city water system began, a new city hall was built, and Northgate became Avon's first experience with a large housing development.

Housing development exploded again in the 1990s and has not ceased. In this book, a great deal of emphasis is placed on the 1958 dedication of city hall because it was voted for and paid for entirely by the citizens of Avon.

Due to an increase in population, the village of Avon has become the city of Avon. During the 1960s, the state decided to build Interstate 90 through the middle of Avon from west to east. Avon had two interchanges. Much discussion occurred about the dogleg at Center Road, Chester Road, and Interstate 90.

With a present population of over 13,000, Avon continues to grow and build itself into a prosperous community eagerly awaiting the future. Many descendants of the first settlers can be traced to the families living in Avon. Many of the first settler's homes are still present around town.

While the images in this photographic history of Avon are only a small representation of the richness of a small town, they do represent the people, places, and events that make up this remarkable community.

One

FAMILIES AND
HOMESTEADS

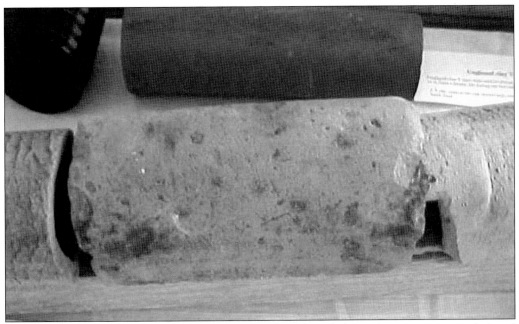

FIELD TILES. The first field tiles were four wooden boards nailed together in a square and placed in the ground. When the kilns were built, the tiles were molded like a horseshoe and placed in the soil on a board. Later tiles had several shapes such as round and six-sided. Today, tiles are long, round plastic coils laid in the ground.

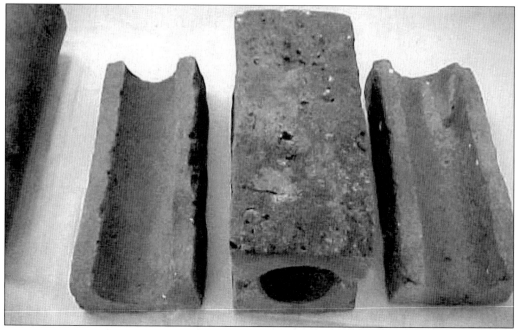

ORIGINAL TOWNSHEND TILES. Pictured are some of the original field tiles from the farm of Dr. Norton S. Townshend (1815–1895). Townshend was born in Northamptonshire, England, and came to Avon in May 1830 with his uncle Isaac, until his father was able to come to the United States. Joe, Norton's father, then purchased 150 acres of land in Avon. Throughout the 1830s, the Townshend family was the first in Ohio to install tile drains under all their fields.

DEDICATION OF THE TOWNSHEND MARKER. Avon graduates of Ohio State University are seen here at the dedication of the Dr. Norton S. Townshend historical marker. Townshend was a founder of Ohio State University.

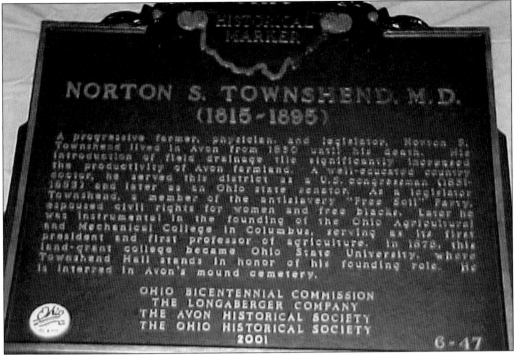

CLOSEUP OF THE MARKER. Dr. Norton S. Townshend was a progressive farmer, physician, and legislator at his residence in Avon from 1830 until his death. His introductions of field drainage tiles significantly increased the productivity of Avon farming. A well-educated country doctor, he served his district as a U.S. congressman from 1851 to 1853 and later as an Ohio state senator.

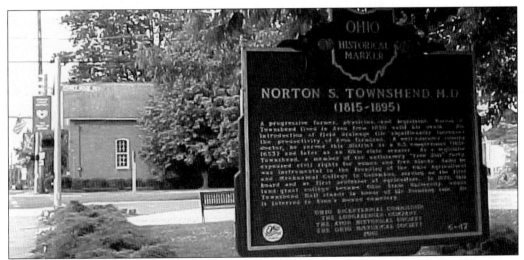

THE MARKER IN THE PARK. The Dr. Norton S. Townshend historical marker is located at corner of Stoney Ridge and Detroit Roads. Here it is depicted with the Old Town Hall of 1871 in the background. Townshend was instrumental in the founding of the Agricultural and Mechanical College in Columbus, serving as its first professor of agriculture. In 1878, this land-grant college became Ohio State University, where Townshend Hall stands in honor of his founding role. Townshend is interred in Avon's Mound Cemetery.

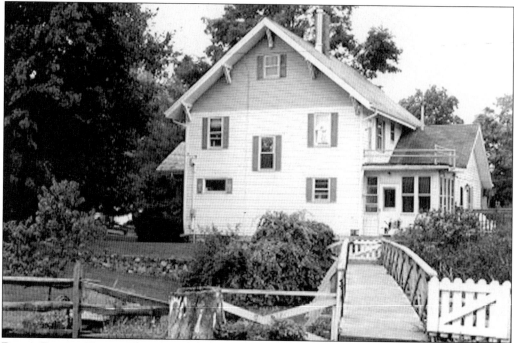

RIDGE BRIDGE FARM. The Ridge Bridge Farm of 1900 is located at 34390 Detroit Road. John T. and Rose R. Forthofer originally owned this Craftsman-style farmhouse. The house sits on 36 acres of land between Jaycox and Nagel Roads. The farm was part of the large property owned by Dr. Norton S. Townshend. (Photograph courtesy of Karen and Skip Conant.)

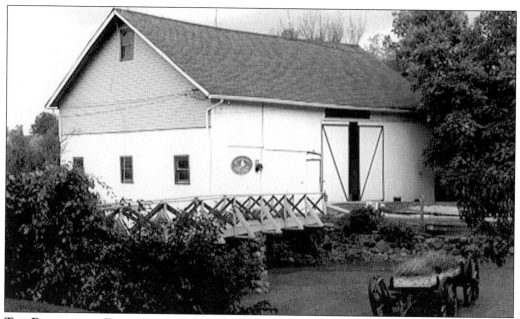

THE BRIDGE AND FARM OF 34390 DETROIT ROAD. Here is picture depicting where the Ridge Bridge Farm receives its name from. The large bank barn and bridge were built several years after constructions of the home. (Photograph courtesy of Karen and Skip Conant.)

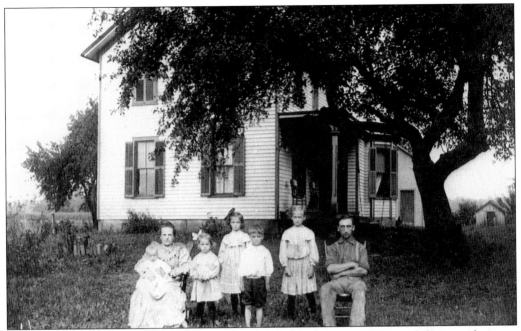

BALDAUF FAMILY, 1908. Members of the Baldauf family pose in front of their residence at 4391 Jaycox Road. From left to right are mother Anna (Mohr) Baldauf, age 29; Norbert, age 1 (on Anna's lap); Mildred Baldauf Horwedel, age 4; Mary Baldauf Krage, age 8; Walter Baldauf, age 9; Viola Baldauf Conrad, age 10; and father Frank Baldauf, age 34. (Photograph courtesy of Debbie Chappo, granddaughter of Mildred.)

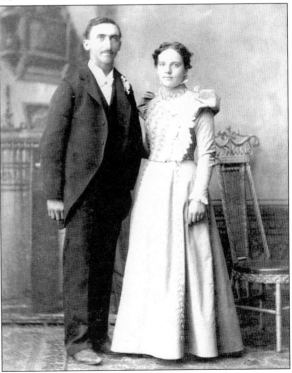

WEDDING PORTRAIT, 1898. This 1898 wedding portrait shows Anna Mohr Baldauf and Frank Baldauf. Anna was born in 1879 and died in 1935. Frank was born in 1874 and died in 1941. These are the parents of Mildred Baldauf in the previous family picture. (Photograph courtesy of Debbie Chappo, granddaughter of Mildred.)

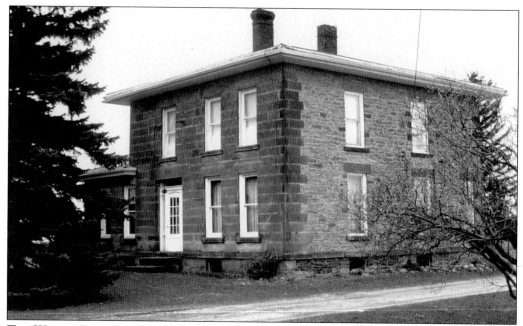

THE WILSON-BALDAUF HOME. The Wilson-Baldauf home (1845) is located at 3260 Center Road on the corner of Kinzel and Center Roads. Ebenezer Wilson, just prior to the Civil War, built it. Wilson was a 34-year-old immigrant from Northhampshire, England. A practical man, he came with a deed to 180 acres from the Connecticut Land Company and promptly put up a log cabin. Amherst sandstone blocks were hauled in. The five-foot-thick foundation tapers to three-foot-thick walls. Plaster was mixed with horsehair and, as one owner once said, is hard as iron.

SMITH BUILDING. This handsome neo-Colonial building, dating from 1940, is located at 35800 Detroit Road. It originally housed the medical office of Dr. Taylor Smith. Later it was Country Heirs, a well-known antique store, and was then split from some of the land that became Avon Commons. In the spring of 2005, it became the Vintage House Café, decorated with photographs from Avon's history.

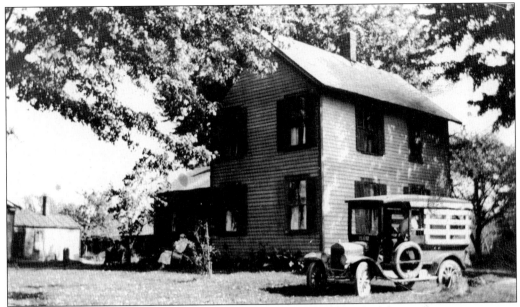

BARRET HOME. The Barret home (1876) was located at 37491 Detroit Road. This house is part of the John Benham Allotment (Hayes Street and Centennial Avenue), built during the 100th anniversary of the American Revolution on land from the Wilbur Cahoon property. Richard Barrett owned a carriage factory on the site of today's Avon Animal Hospital, making buggies, sleighs, and cutters. He was killed in 1922 when a load of hay fell on him.

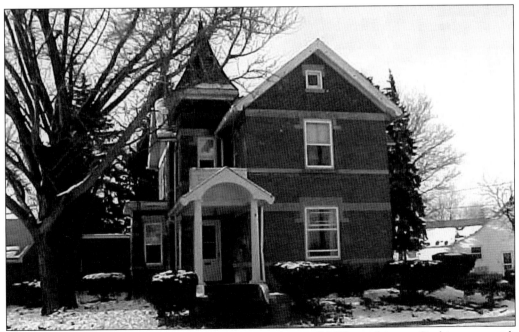

HERMAN BARROWS HOME. The Herman Barrows house (1860) combines a Gothic tower with Greek Revival architecture. The home is located at 38135 Colorado Avenue. Dorothy Gauchat was cofounder with her husband, William, of Our Lady of the Wayside Home for Children at the Barrows home.

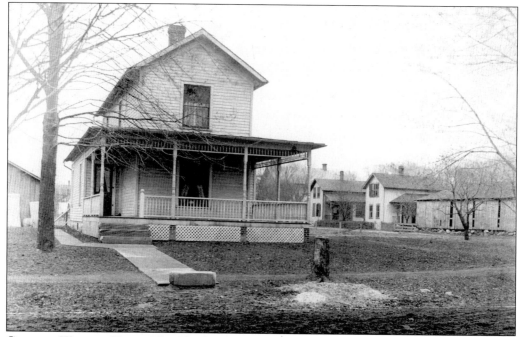

CHARLES WAGNER HOME. The Charles Wagner house (*c.* 1850), at 2552 Stoney Ridge Road, was built by George Burrell and was later occupied by A. C. Hale (Hale Street). Alma Sturznickel said in *The Talking Quilt* video that John Wagner, her grandfather, was a blacksmith on the site of the Avon Animal Hospital. Another blacksmith faced him across Detroit Road. When John Wagner would get too busy, he would ring a bell to summon the other blacksmith for help. Alma's father, Charles Wagner, converted the smithy into an automobile repair shop and gas station.

PRIMITIVE AMERICAN ART. In a small store in Fort Pierce, Florida, a gentleman by the name of Peter Gannon purchased a pencil drawing that he considered a nice example of primitive American art. The drawing consists of a two-story house and a log cabin. The signature at the bottom is that of Joseph A. Schwartz. An inscription on the drawing reads, "1853, Schwartz Farm, Avon, Ohio. Log Cabin Built 1816." Another inscription states, "Family Homestead and Original Buildings by Muriel's Father, Joseph A. Schwartz, Avon, Ohio. Site of Farm."

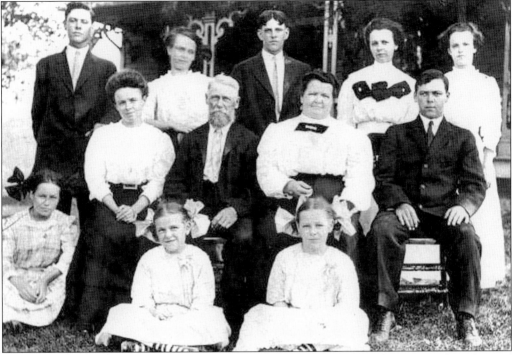

SCHWARTZ FAMILY. Taken around 1920, this photograph shows the Schwartz family in front of their home on Schwartz Road. From left to right are the following: (first row, sitting) Martha, Blanche, and Dorothy; (second row) Annie (Krebs), Simon, Anna (Sullivan) Schwartz, and Peter; (third row) Louis, Helen (Smith), Leo, Ella (Forthofer), and Agnes (Urig).

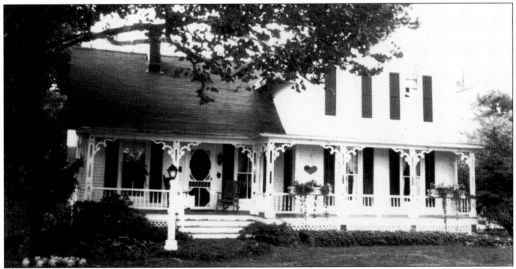

PETER SCHWARTZ HOME. The Peter Schwartz house (1845) is located at 34745 Schwartz Road. Peter and Mary Schwartz arrived from Germany in 1842 but lived in a log cabin until Peter's brother, John, built this lovely structure. Another Peter Schwartz passed away in 1969, and the home was for the first time owned by someone other than a Schwartz. At one time, a relative lived upstairs, where he had a barbershop, sold candy and gum, and repaired shoes. (Photograph courtesy of Jean Fischer.)

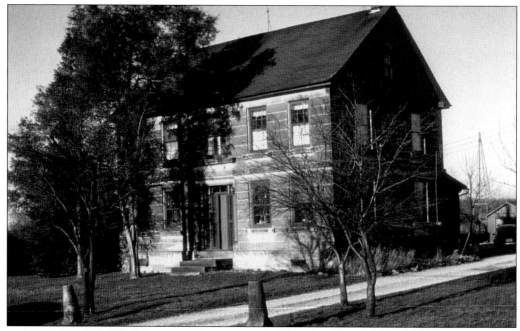

JOHANNES NAGEL HOME. This Greek Revival sandstone house is at the corner of Nagel and Schwartz Roads. It was constructed in 1849 and built to last for centuries. The walls taper in thickness from 40 inches in the foundation to a first-floor thickness of 24 inches and 18 inches at the second floor. Wooden pegs were used throughout the entire house. John (Johannes) Nagel passed away in 1974 at age 85.

ROY AND GRACE CAHOON. Roy Cahoon was the last living descendant of Wilbur Cahoon, Avon's first settler, to live in Avon. Roy was born in 1893. He married Grace Peak and farmed his 71 acres, the Ora Butler Cahoon homestead, his entire life. He was a veteran of World War I. He was a truck farmer, taking his produce in his truck to the Cleveland market.

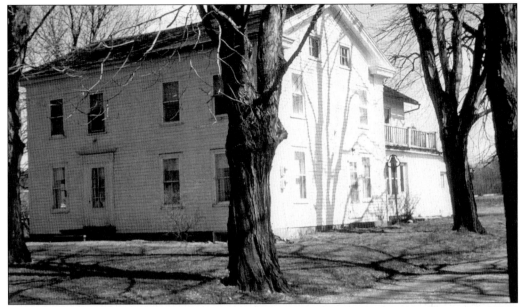

ORA BUTLER CAHOON HOME. The Ora Butler Cahoon home (c. 1845) is located at 37821 Detroit Road. This beautiful home just west of the Avon Methodist Church was built in 1845, a wood-frame structure with a sandstone foundation. A large basement beneath the dwelling features hand-hewn beams, a well to provide fresh water, and sample storage for food. Electricity was installed in 1927. Ora Cahoon died in 1881. His grandson Roy and Roy's wife, Grace, lived in it until they both passed away in 1986. (Photograph courtesy of Jean Fischer.)

WILBUR CAHOON HOME. The Wilbur Cahoon house (c. 1825), located a quarter of a mile south of Detroit Road on Stoney Ridge overlooking the French Creek, is one of the oldest frame houses in Lorain County, built in 1825. The house is 80 feet long and has 12 rooms. Wilbur Cahoon, Avon's first settler in 1814, became owner of both the sawmill and gristmill. Wilbur died before the house was finished. (Photograph courtesy of Jean Fischer.)

CHARLES WARDEN HOME. This Italianate house was built for a daughter of Leonard Cahoon, a son of Avon's original settler Wilbur Cahoon. It is located on Centennial Avenue. The downstairs rooms have high ceilings and very ornate woodwork. The basement walls are made of large stones.

STONE EAGLE FARM. William E. Hurst's home was built in 1843 on the east end of the city on the south side of Detroit Road. A 1974 article in the *Press* observed that the house had been included on the National Register of Historic Places. The article remarked that the structure is an unusually fine example of stone masonry house in the Greek Revival style. Built on over 600 acres on Detroit Road, the house was once the largest on Cleveland's west side.

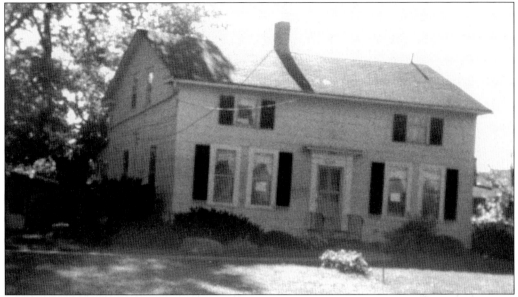

JAMESON HOMESTEAD. The Joseph B. Jameson house was located on the south side of Detroit Road east of the post office where a drugstore once stood. It is said that the house was built over a log cabin. The structure was torn down in the 1980s. Joseph B. Jameson was born in 1787 in Dunbarton, New Hampshire, and died in 1867 in Avon. (Photograph courtesy of Jean Fischer.)

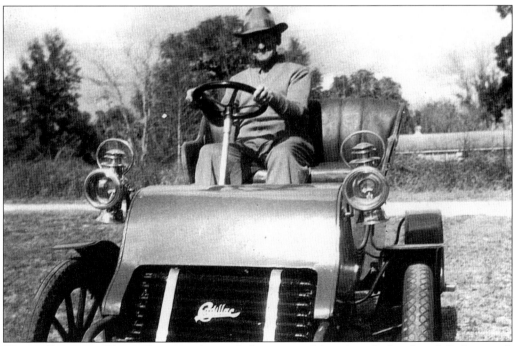

HOMER JAMESON. Homer Jameson descends from one of Avon's early families. J. B. Jameson's daughter, Thankful Jane Jameson, married Ora Butler Cahoon, son of Wilbur and Priscilla (Sweet) Cahoon, in 1834. Avon farmers were experts at using dynamite to blow up stumps and glacial boulders. Homer was among the best of them.

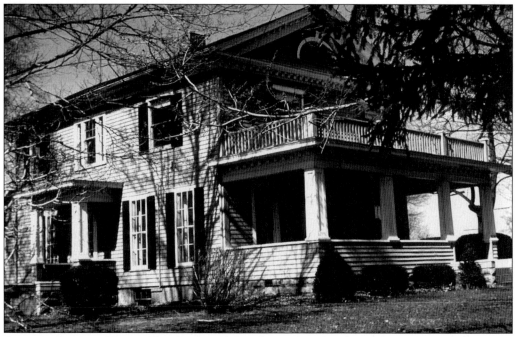

George Clifton Home. The George Clifton home (1848) is located at 36368 Detroit Road. This is an unusual house because its doorway is Greek Revival, but the detailing, especially the pediment, is Georgian. Perhaps Clifton modeled this house after his old homestead in England. George Clifton (1811–1883) came to this area from North Hamptonshire, England, to establish his farm.

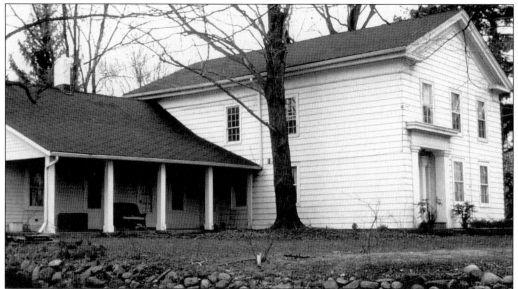

George Sweet Home. The George Sweet home was built in the late 1820s or early 1830s on the site of his original log house. The Sweet home is of Greek Revival architecture with the familiar two-storied main house with a one-story wing. The main house has six spacious rooms and a beautiful open stairway with large halls on both floors. Foundation beams are logs 16 inches by 20 inches thick; some still have bark on them.

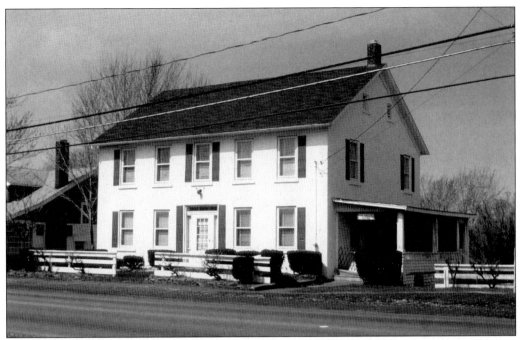

ALTEN CASPER HOUSE. The Alten Casper House (*c.* 1850) is located at 36840 Detroit Road. This historic home, the front house of Olde Avon Village, is the original farmhouse of the Mathias Alten property. There is a full attic and a full basement with a stone foundation. The interior dividing walls of this brick house are also brick. Mathias Alten came to Avon with his parents in 1845. In 1896, Mathias's youngest child, Rosa Alten, married Peter Casper.

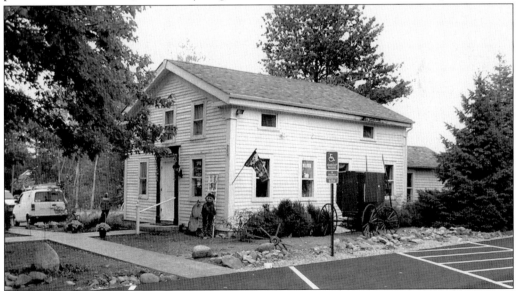

GIBBS-BINNS HOME. The Gibbs-Binns home is located at 36840 Detroit Road. Jonathan Gibbs built the house around 1850 on the east side of Stoney Ridge. Peter Binns bought the house in 1890 and used the property for a store and home. The store became a post office in 1920 and, in 1968, became Smitty's Barber Shop. In 1933, Dr. Taylor Smith rented the house and began his practice there. The house was moved in 1987 to Detroit Road in Olde Avon Village.

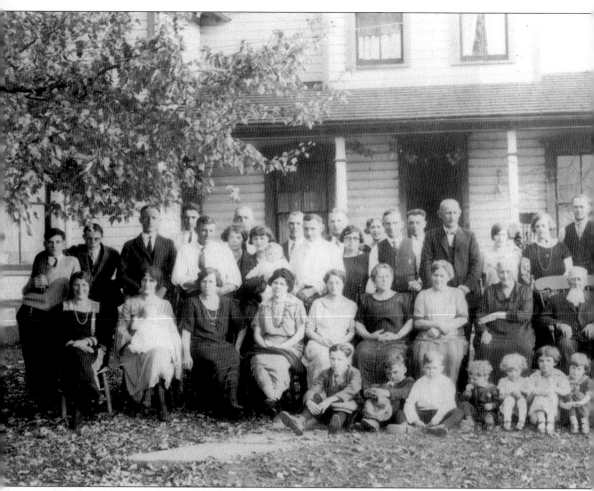

WEARSCH FAMILY. One of the best-known family names in Avon is Wearsch. In the late 1880s, John Wearsch settled here in Avon after leaving his homeland of Koblenz, Germany. This 1923 family reunion—attended by descendants of John Wearsch (born in 1839) and his wife, Anna

(born in 1845)—was held in the Wearsch homestead, located near St. Mary of the Immaculate Conception Church. Tom Wearsch's grandfather, Peter (born in 1869) and his wife, Mary Weinzel Wearsch (born in 1876), are also in the picture. (Photograph courtesy of Tom Wearsch.)

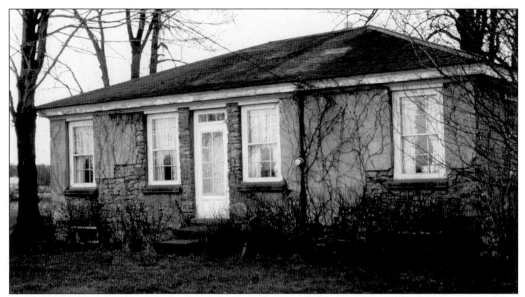

LEWIS HOME. The Lewis house (*c.* 1843), originally at 1591 Center Road, is now at Olde Avon Village. In 1851, the property passed into the hands of John Blackwell Sr. In 1929, the property was owned by Howard and George Lewis, who in the 1930s sold some of the "back land" with frontage on Detroit Road to Taylor and Evelyn Smith. This land is where Dr. Smith built his medical office at 35800 Detroit Road. It has been stated that this house is the only pyramid-roofed, square stone home in Ohio. The house also won an award by the Lorain County Beautiful Awards Program, nominated by the French Creek Development Association, in 2003.

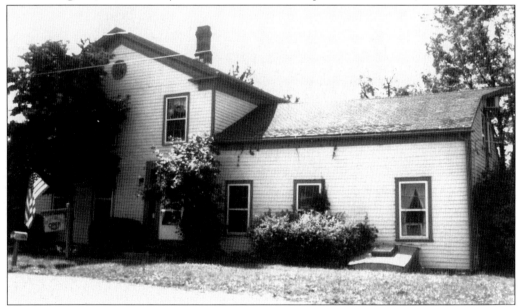

WILLIAMS HOME. The first recorded owner of the Henry Harrison Williams house was Calvin Bronson, who acquired it in 1836 and sold it to Henry Harrison Williams in 1844. He established and operated a mercantile business in the house, which is built of native wood cut at the H. H. Williams Sawmill and Lumber Yard. The house is on the National Register of Historic Places. (Photograph courtesy of Jean Fischer.)

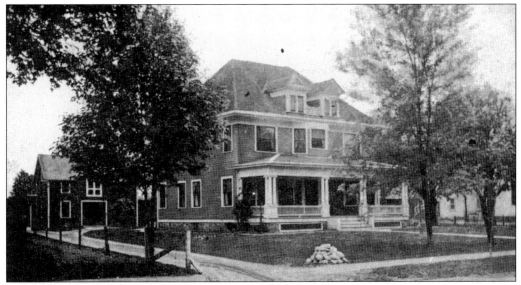

DOCTOR'S HOME. This home is located on the south side of Detroit Road just west of French Creek Road. Dr. Pipe, the owner of the house in the early 1900s, was one of the area's last horse-and-buggy physicians.

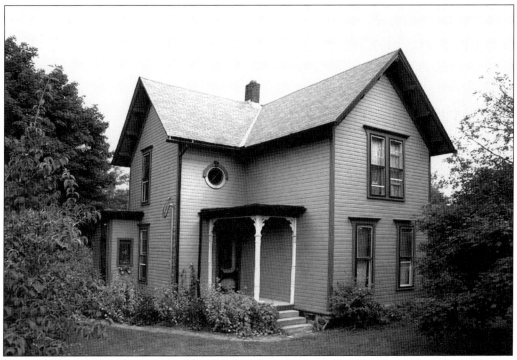

ELBRIDGE G. MOON HOME. The Elbridge G. Moon home (c. 1857) is located at 39200 Detroit Road. This eight-room early-Victorian house was built on the site of the original cabin of Col. Abraham Moon. It had ornate grained woodwork, grained pocket doors, 10-foot ceilings, and no fireplaces. It was heated with wood stoves. E. G. Moon excelled as a horticulturist and raised Jersey cows. (Photograph courtesy of Ann and Richard Bort.)

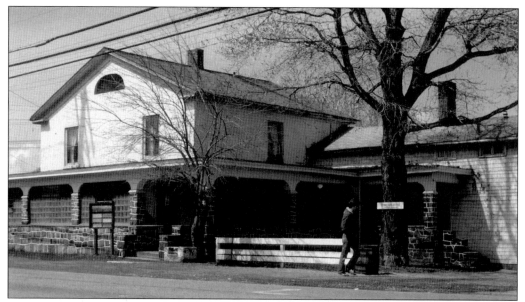

CLEMONS ALTEN HOME. The Clemons Alten home (*c.* 1850) is located at 36976 Detroit Road. There is speculation that the main brick structure was added to a smaller building, "the kitchen," where the family lived from 1850 to 1860. The massive wraparound porch was added in 1905. Hardwood floors are used throughout the house, and all main interior walls are brick. The building now houses Nemo's Grill.

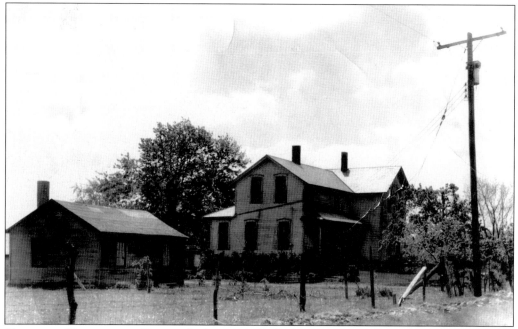

GUTZMAN HOMESTEAD. Here is the homestead of John and Hattie Gutzman, located at 4601 Nagel Road. It was originally built by M. Deidrick in 1883, sold to the Krebs family in an unknown year, and purchased by John Gutzman in 1933. The small garage-sized house on the homestead was the blacksmith for the farm. (Photograph courtesy of Joann C. Gutzman Albert.)

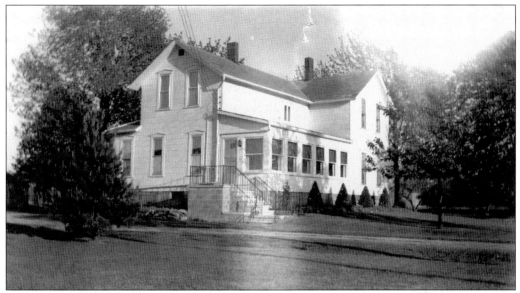

REMODELED GUTZMAN HOUSE. John Gutzman reshingled the house and had a fresh coat of paint put on in the 1940s. Both front and back porches were enclosed by 1950. The home was sold in 1975 by the Gutzman heirs and, in July 2004, was torn down. (Photograph courtesy of Joann C. Gutzman Albert.)

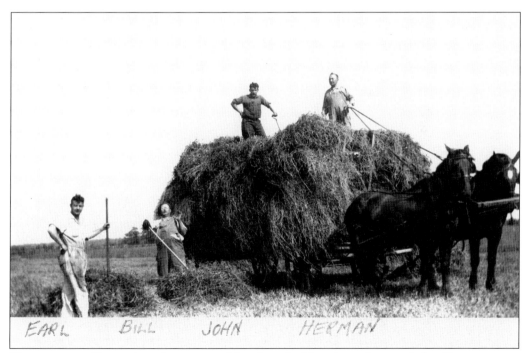

HARVESTING. Harvesting time was real hard work. Here is a picture of the Gutzman men tending to their 85½ acres of land. From left to right are brothers Earl Gutzman, Bill Gutzman, and John Gutzman with their father Herman Gutzman. (Photograph courtesy of Joann C. Gutzman Albert.)

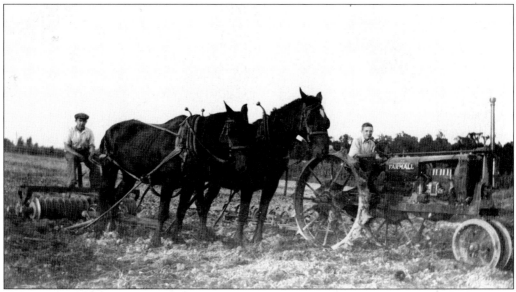

WORKING THE LAND. Here man and machine are working the land together. Pictured on the horse plow is John Gutzman, the father. His son Hank Gutzman is on the tractor. (Photograph courtesy of Joann C. Gutzman Albert.)

FENCE OF FRIENDS-BROTHERS. This photograph was taken in 1916 along a homestead on Stoney Ridge Road. Avon's current mayor, James A. Smith, was quick to point out that the young man on the left is his uncle Albert, and on the right is his father, William Smith. (Photograph courtesy of Mayor James A. Smith.)

TAKING CARE OF THE CHILDREN. A nanny poses with some of the Wilford children in front of the Old Town Hall. The children are Chuck (in buggy), Laura (behind buggy), Bud (foreground), and an unidentified child. (Photograph courtesy of Mayor James A. Smith.)

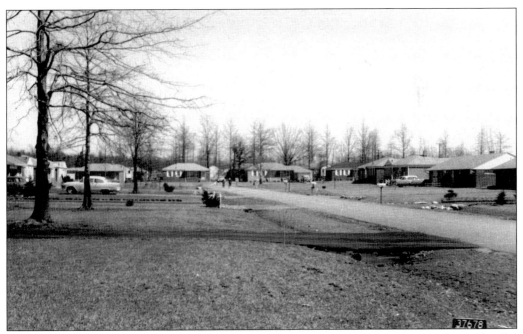

NORTHGATE COMMUNITY. The Northgate development was constructed in the mid-1950s north of Route 611 and west of Detroit Road. This view looks east on Lori Street toward Eaton in 1959. (Photograph courtesy of Ralph White.)

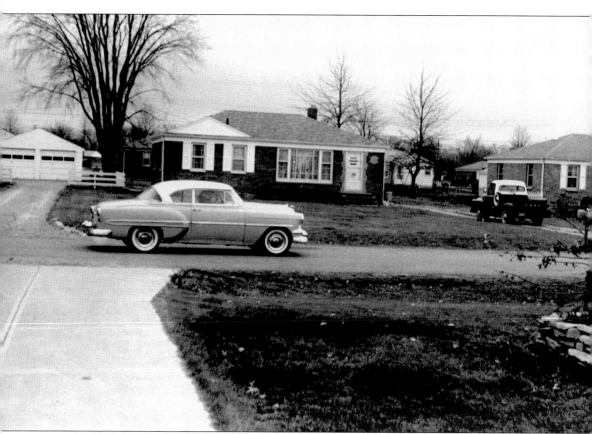

HOMES OF THE 1950S. The building of these homes, originally not very popular with Avon residents at the time, offered a well-built home for the money. A new house in Northgate would cost between $12,000 and $16,000. (Photograph courtesy of Ralph White.)

Two

MEMORIES OF AVON

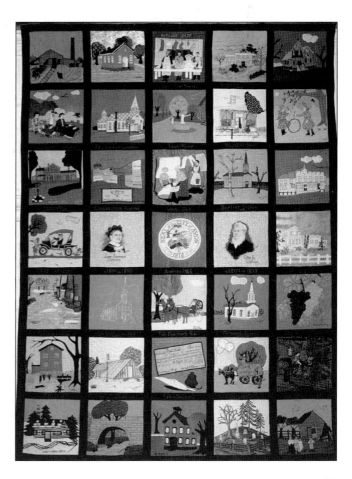

THE ENTIRE QUILT. The quilt, completed in 1976, was a community project under the sponsorship of the Avon Historical Society. This was a way to help America celebrate the upcoming bicentennial. The original plan was to have 30 squares, but so many wanted to join in the project that the number of squares was increased to 35.

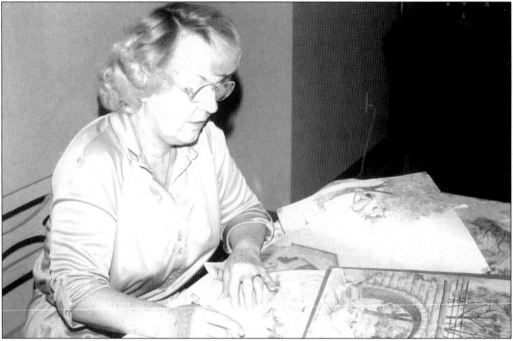

BETTY SHEAK DRAWING. The sketches were black-and-white drawings made by artist Betty Sheak from photographs provided by Alma Sturznickel. Alma's uncle was Frank Wagner, who was a very talented local photographer. The photographs were from 1814 to 1914.

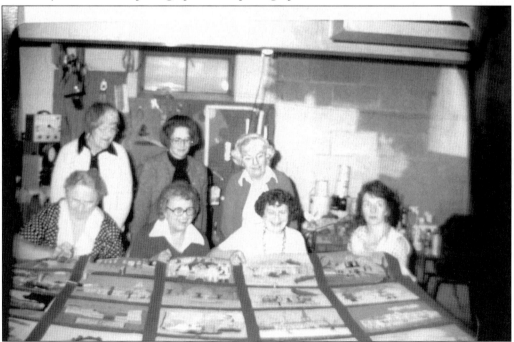

BLOCK WORKERS. The ladies, "block workers" as they called themselves, were told to let their own imaginations be their guide. They could use whatever fabrics, colors, and stitching techniques they liked.

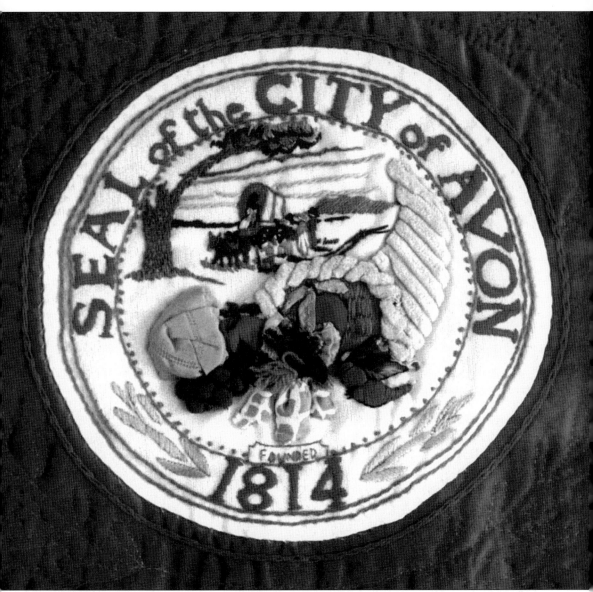

SEAL OF AVON. This is the official seal of the city of Avon. Susan Jaworowski did the needlework. The seal reflects Avon's rural atmosphere and the abundance of truck gardens, small farms, and greenhouses.

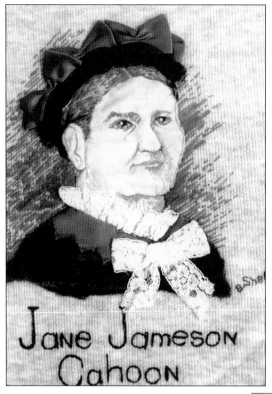

Jane Jameson Cahoon

THANKFUL JANE JAMESON CAHOON. Thankful Jane Jameson Cahoon's father, Joseph B. Jameson, must have been doubly thankful, because Thankful was also his wife's name. Thankful Jane was born in New Hampshire on September 14, 1814, and married Ora Butler Cahoon. Betty Sheak did the needlework this square, and the next, Ora Cahoon.

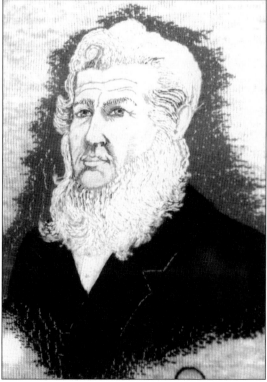

ORA CAHOON PORTRAIT. Ora Butler Cahoon was a lad of 10 when his parents Wilbur and Priscilla Cahoon moved here from New York State in 1814. Ora married Thankful Jane Jameson in 1834, but in 1848, he passed away, preceding his wife by more than 40 years.

BAPTIST CHURCH. The Avon Baptist Church is the oldest church building in Avon. It has been in continuous use for over 140 years. Pat Wearsch did the needlework on this square.

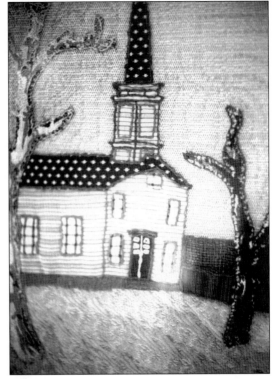

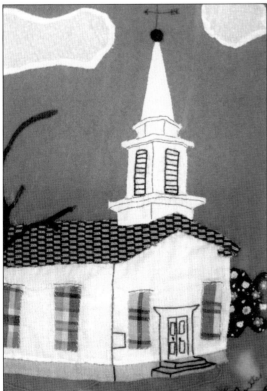

METHODIST CHURCH. This church was built in 1855 and served as a house of worship until 1911, when it was destroyed by fire. Anita Stockard did the beautiful needlework.

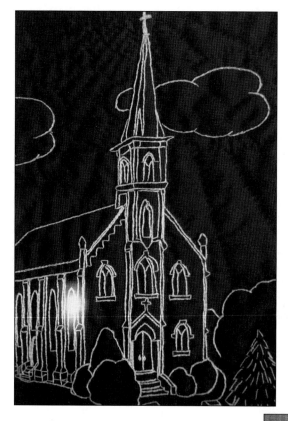

ST. MARY'S CHURCH. St. Mary's Catholic Church was built in 1895. It was the second Catholic church in the parish, and its towering spire can be seen from many miles distant. Judy Haas did the needlework on St. Mary's.

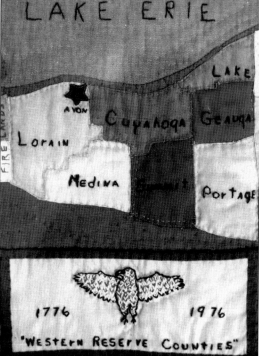

MAP OF THE WESTERN RESERVE. After the Revolutionary War, Connecticut "reserved" certain lands by not turning them over to the new federal government. The land was bought by the Connecticut Land Company. The 35 men in the company drew lots to see what they each owned. For $60,000, Pierpont Edwards drew Avon. Mary Peterson did the needlework.

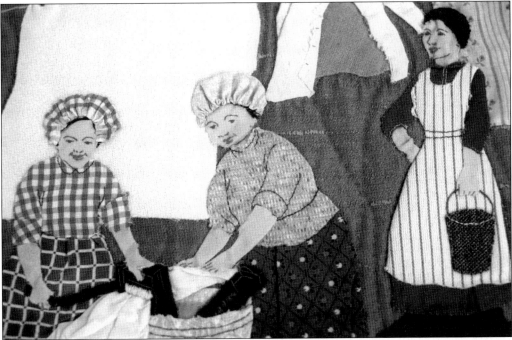

WASH DAY. Betty Sheak not only made this sketch but did the needlework as well. The image is based on a photograph taken on the Rink farm on Long Road, depicting a tiresome, neverending chore of wash day.

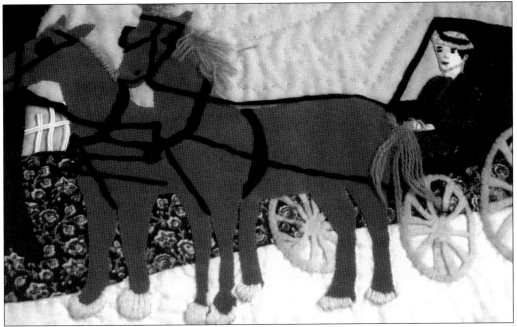

HORSE AND BUGGY WITH DOCTOR. Avon was never without a physician. The physicians made house calls in horse-drawn carriages. The figure is that of Annie Kiehm, the nurse who assisted Dr. Cox. Clara Guggenbiller, who did the needlework on this square, is the great-niece of the same Annie Kiehm.

SAWMILL. Joseph Jameson was born in Avon in 1833 and, when he was 40 years old, began to operate this sawmill that was tucked away along the west banks of French Creek. This fine needlework was done by Joseph Jameson's granddaughter, Doris Jameson Kaswell.

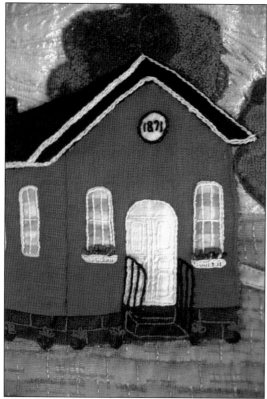

OLD TOWN HALL. The Avon Historical Society took on the task of refurbishing the town hall. It was built in 1871 and was in the center of town. Mary Homenik captured the spirit of it all with her needlework on this lovely square.

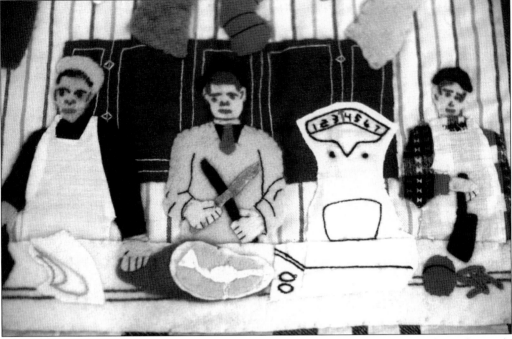

CORNER MARKET. Most people living in Avon will remember the building where this early meat market was located as Gelman's grocery. Mary Linden did the very nice needlework.

STONE EAGLE FARM. When the Hurst brothers came to Avon from England, Will Hurst erected this house in 1843. It is on Detroit Road, just west of Elmhurst Cemetery. Carole Bartolovich, in whose home the assembling and quilting was done, did the needlework on Stone Eagle Farm.

METHODIST CHURCH. Soon after the old Methodist church was destroyed by fire in 1911, this one was built on the same site, the south side of Detroit Road just a few yards east of Hayes Street. It is now owned by the Church of God. Bernice Stumphauser did the needlework.

PEOPLE. This square is all Bety Sheak's work and is called *Sunday Afternoon*. One of the figures is Matt Lenzen, whose father owned the entire southwest corner of Detroit Road and Colorado Avenue from Buck's Hardware to Stoney Ridge, where Lenzen's Drug Store once operated.

HOLY TRINITY CHURCH. The oldest Roman Catholic church in Avon, the first Holy Trinity Church was built in 1848. By the time the Civil War exploded on the nation, little Holy Trinity had to be enlarged, and an addition of a sanctuary and sacristy was made. The church then had two steeples, as shown here in the needlework by Margaret Sproul, until the present structure was erected.

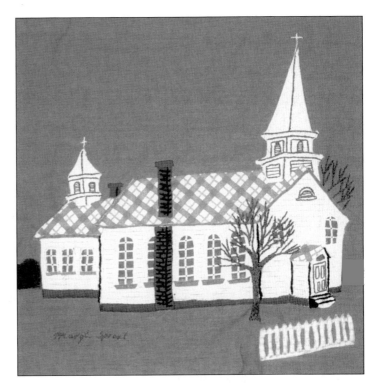

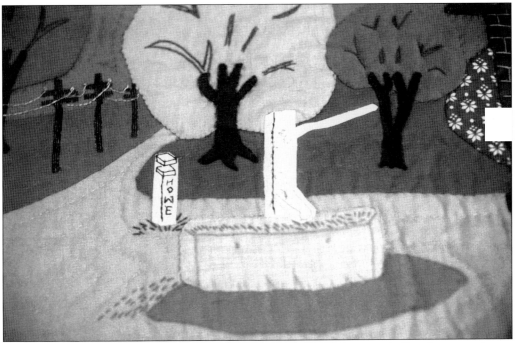

WATER PUMP. People who could not get water used to go up to the town hall and pump it. It was located in front of the Old Town Hall along with the watering trough and the weighing scale. Olivia Heinebrodt and Marie Rak teamed up on this needlework.

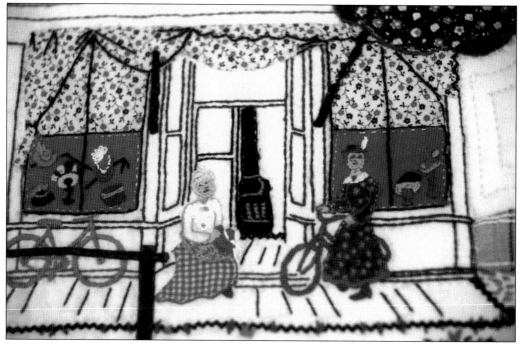

LADY'S STORE. This square, called *The Millinery Shop*, belonged to May Weber. She operated the shop and dry goods store for many years. She sold everything from schoolbooks, supplies, thread, and doilies. May is to the left, next to Lizzie Taft. The needlework was by Debbie Bommer English.

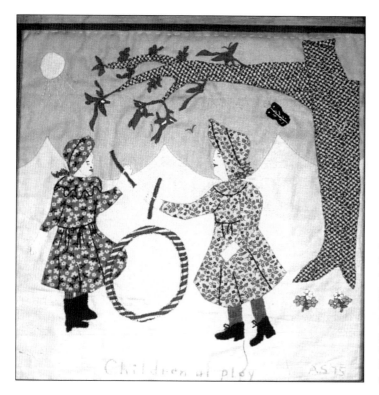

CHILDREN AT PLAY. *Children at Play* was not from any photograph or painting but merely represents the type of clothing and the games played by little girls during the time. Alberta Stauder's needlework captures the flavor.

WILFORD HOTEL. Built in 1842, this home was sold to Reuben Wilford in 1850, and he converted it into a thriving hotel, which remained a landmark for over a century. It was located on Detroit Road just west of French Creek Bridge.

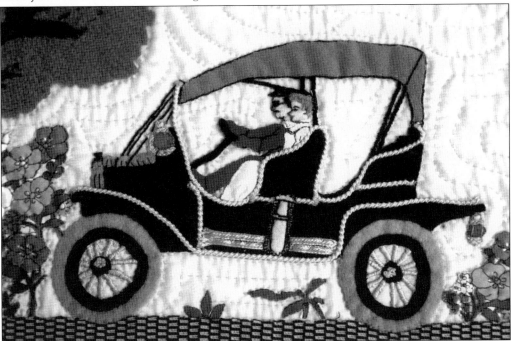

CADILLAC CAR. This 1908 Cadillac was a familiar scene on the roads of Avon back then. It was not too popular with anyone who owned a skittery horse. It was owned by H. B. Martindale, the grandfather of Laura Wilford Forthhofer, who did the very nice needlework.

A VERY BAD WINTER. In the winter of 1912–1913, the French Creek ran wild. Heavy ice jammed it up and threatened to wash out the bridge over French Creek on Detroit Road. The water was three or four feet deep over the road at the time. Catherine Schuster's fine needlework clearly shows this awesome scene.

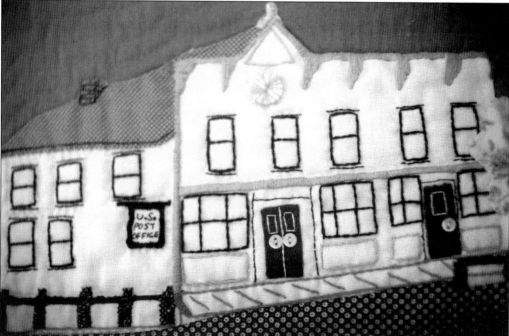

POST OFFICE. The old post office stood at the corner of Detroit Road and Colorado Avenue, next to where the old Alten house stands. It served as a lot of things other than a post office; it was a hardware store, a general store, and at one time a grocery store. Mary Louise Zeise did the fascinating needlework on the post office.

46

CAHOON HOUSE. One of the finest and best-maintained examples of Colonial architecture in Avon, this century home was built by Wilbur Cahoon, the original settler. Located on Stoney Ridge, the home overlooks French Creek. Jean Fischer did the needlework for this lovely square.

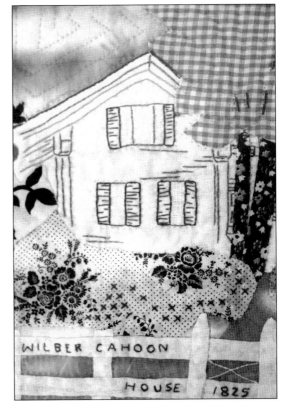

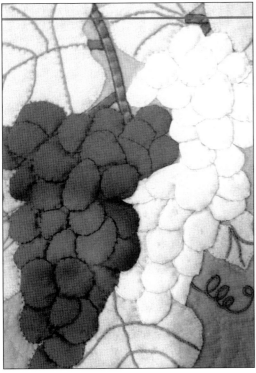

VINEYARD GRAPES. Grapes represent the importance of the plant in the history of the entire Western Reserve. To this day, wineries dot the countryside. Irene Kelling did a beautiful job with her colorful needlework.

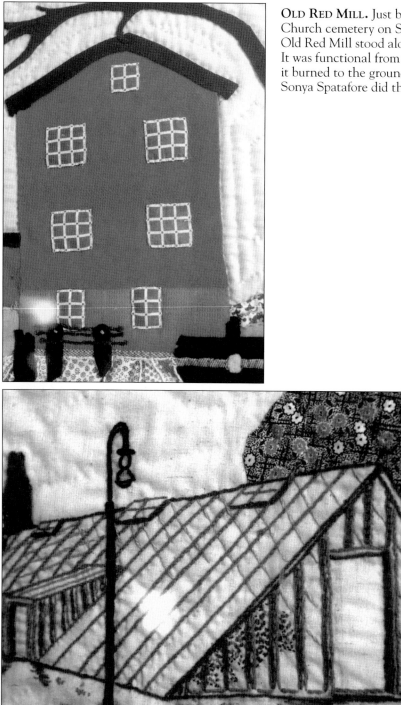

OLD RED MILL. Just behind St. Mary's Church cemetery on Stoney Ridge, the Old Red Mill stood along French Creek. It was functional from the late 1800s until it burned to the ground in the late 1950s. Sonya Spatafore did the needlework.

GREENHOUSE. Evelyn Chapman did the needlework on this square. Lieber's greenhouse was in use in the late 1800s. It was located on the west side of Colorado Avenue, where Irene Lieber Harold and her husband, Oscar, now live.

48

Land Tax Receipt

ceived of Martin Rink
85 cents, and 9 Mill
harged in the year 1853, on the property

Range	Town	Sec.	Personal Property	acres
16	7	11		85

Treas Office, EL 1853

DOCUMENT SECTION. Frances Rink did the needlework for this square, showing a tax receipt on 85 acres of farmland owned by the Rink family. The property, on Long Road, extended east to Stoney Ridge Road. Part of the farm on the eastern section is where Tom's Country Place is located.

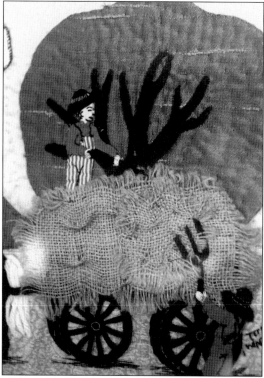

HAY WAGON. Terry Winter captured the activity that took place each fall at threshing time in this nice bit of needlework entitled *Loading Hay*. Fred Gough and his son are doing the work. Fred's father was an early Avon Baptist minister.

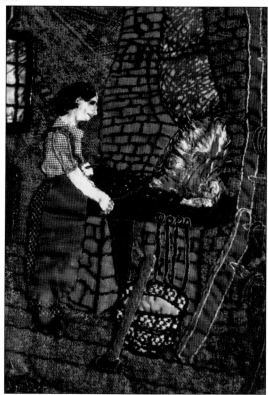

BLACKSMITH. Avon was blessed with two blacksmiths around 1900. Both were located on Detroit Road near French Creek. John Wagner was owner of one shop, and when he got to busy, he would ring the bell to signal his fellow smithy for help. John Wagner's granddaughter is Alma Sturznickel, and she did such a good job on the needlework here.

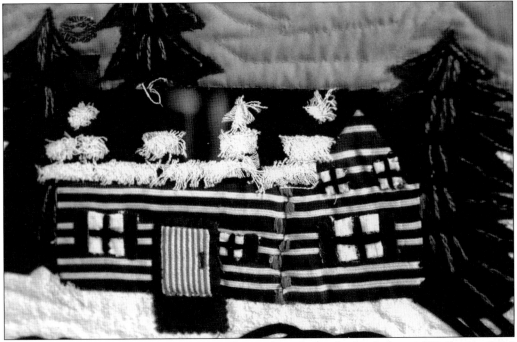

CABIN. This cabin is located along French Creek and was the birthplace of Kathering "Kit" Glasgens, who married George Wagner. George was the undertaker back in the 19th century. Kit was always in attendance to ensure modesty when a deceased female was in their care. Dorothea Lanzendorfer did this very nice needlework.

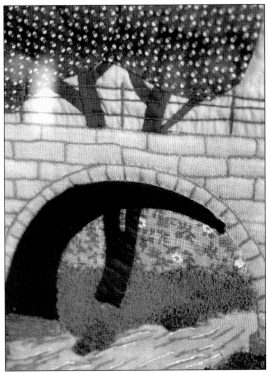

FRENCH CREEK BRIDGE. It is unknown when the stone arch was built, but Margaret Findora's needlework depicts the pastoral setting that was there long ago.

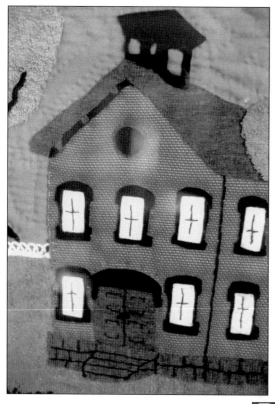

JULIAN SCHOOL. The brick schoolhouse on Julian Street was completed shortly after the Old Town Hall in 1871. It was used first as an elementary and later (with its addition) as a high school. Kathleen Vigneaux captures the charm of the building.

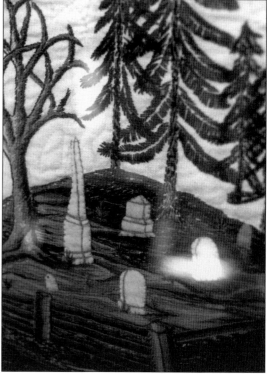

MOUND CEMETERY. Cora Monda's picture of Mound Cemetery shows why many people believe this was an early Indian burial ground and used later by settlers for the same purpose. This cemetery is located at the intersection of Route 83 and Detroit Road. Others believe it is the remains of a sandbar deposited there when the lake receded to the north side of Detroit Road.

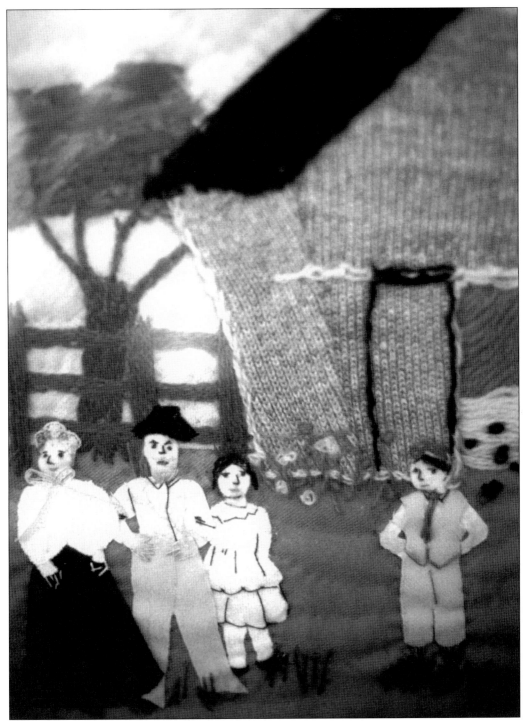

FAMILY PICTURE. The Kinzels, who were also early settlers in Avon, put their roots down in the area about a mile south of Detroit Road on Route 83. Their farm sprawled out over many, many acres, and among the buildings on it was this granary, which sat near the corner of Route 83 and Riegelsberger Road. Carol Ladikos did this excellent needlework.

'Patchwork' comes here

"Ohio Patchwork '76," a traveling juried exhibition of quilts by Ohio textile artists sponsored by the National Endowment for the Arts, will be on view today from 1 to 5 p.m. at the Cleveland Restoration Center, 1244 Huron Road Mall, NE.

Works on exhibition include such group projects as the Oberlin Quilt, the Independence Quilt, the Bowling Green Quilt and "Memories of Avon."

Quilts and quilted hangings by individuals include the photo-silkscreen "Quilted Album: Two Generations" and "Elizabeth's Grandson's World" by Wenda F. von Weise of Gates Mills, the "Cuyahoga Valley — Aerial View" quilt by Lauretta Jones, the batiked "Wall Quilt" by Harriet Russell of Berea, and a cartoon quilt of machine and hand-embroidered stitched ("My Dad Hates the Cat and the Cat Hates My Dad") by the late Gail M. Andrews of Avon Lake.

The 22 quilts and quilted hangings on display were selected from 109 entries by Ohio textile artists in an effort to show Contemporary paths of quilt design.

EDITORIAL. The quilt has been exhibited in the bicentennial celebration in Avon on July 4, 1976. It has also been shown at Bowling Green University, the State Office Tower in Columbus, the Convention Center in Dayton, and the Restoration Center in Cleveland. It was awarded first prize in the Ohio contest, and a silver medal in the national section of the National Quilt Contest sponsored by Good Housekeeping, which had nearly 10,000 entries in the competition.

Three

STREETSCAPES AND THE FRENCH CREEK DISTRICT

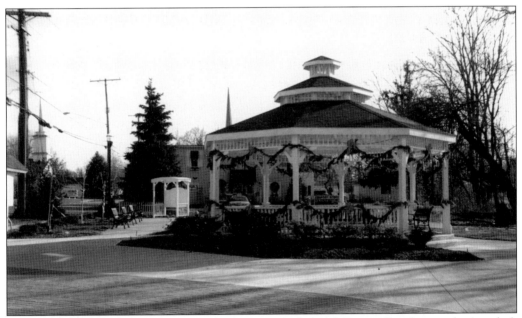

HERITAGE SQUARE PARK. The corner of Stoney Ridge and Detroit Roads was always a hub of Avon's community. A general store once stood there, later to become a bar and eventually becoming vacant. Upon urging by the French Creek Development Association, the city purchased this historically significant parcel across from the original Old Town Hall of 1871. In a joint effort, a gazebo, walkways, benches, and trees were installed to form a town square named Heritage Square Park. The park was dedicated in 1999. In 2001, the French Creek Development Association had a Cat's Meow miniature replica of the gazebo, and local merchants sold it. (Photograph courtesy of French Creek Development Association.)

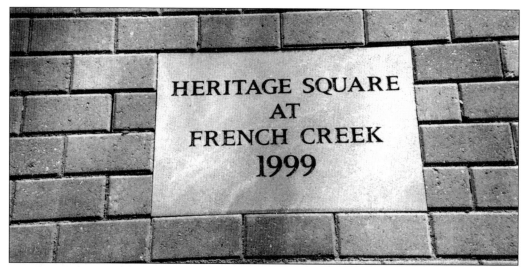

THE BRICK PATH. Bricks were purchased by local citizens to help support the construction of Heritage Square Park. The names of the citizens who purchased the bricks were engraved on the brick. The bricks were laid at two locations. The first location is at Heritage Square Park on the corner of Stoney Ridge and Detroit Roads. The second location is at the Centennial Plaza Clock in front of the police station on Detroit Road. (Photograph courtesy of French Creek Development Association.)

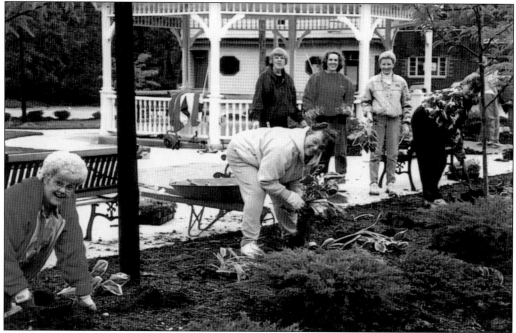

AVON'S PRIDE DAY. Every second week of May, Lorain County dedicated a Saturday called Pride Day. On Pride Day, the cities conduct spring cleanup. Here, members of Avon's Garden Club and French Creek Development Association are taking pride in spring planting at Heritage Square Gazebo. Pictured from left to right are Colletta Holewecky, Dorrie Boomer, Carol Hartwig, Becky Calderwood, Toni Barnhardt, and Lois Shinko. (Photograph courtesy of French Creek Development Association.)

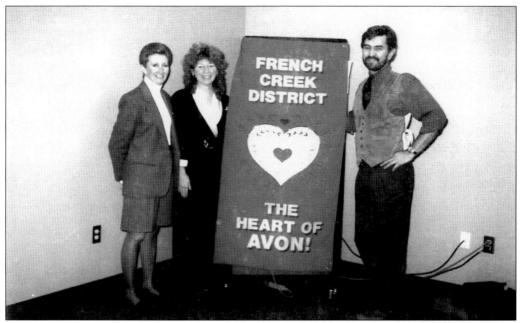

THE DISTRICT BANNER. This is one of several projects that the French Creek Development Association undertook to enhance the streetscape of the French Creek District. A banner program was initiated, and local art teacher Mary Ann Furey won the banner design. Toni Barnhart (left), Karen Brady (center), and Paul Burik display one of the banners that now line the French Creek District. (Photograph courtesy of French Creek Development Association.)

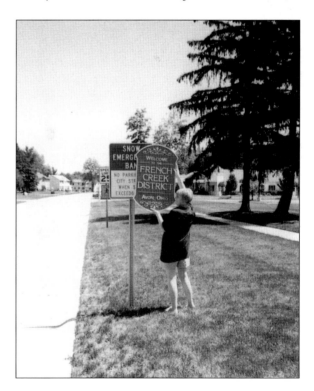

FRENCH CREEK MARKERS. Another project that the French Creek Development Association conducted was the district markers. The markers were placed at the boundaries that define the French Creek District. (Photograph courtesy of French Creek Development Association.)

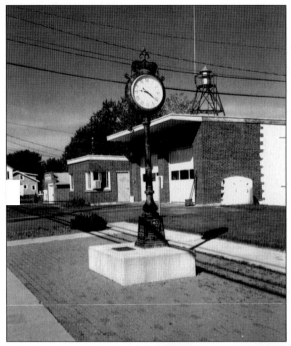

THE TOWN CLOCK. Centennial Plaza, in front of the police station, features a cast-iron clock, benches, and brick pavers. The pavers are inscribed with patron's names. The sale of the inscribed blocks funded this endeavor. In the concrete clock base, a time capsule was placed on the dedication day of September 7, 1997. It is scheduled to be opened in 2016. This year marks the 100th anniversary of the city's charter. This plaza was one of the first accomplishments of the French Creek Development Association. (Photograph courtesy of French Creek Development Association.)

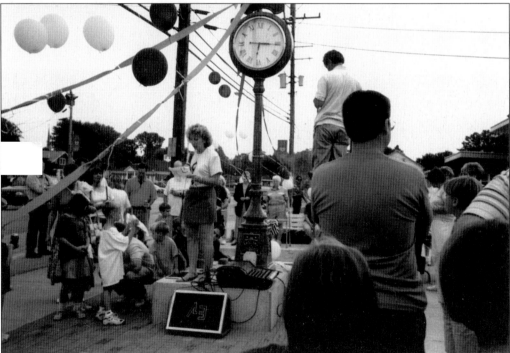

CENTENNIAL PLAZA DEDICATION. The French Creek Development Association commissioned a young, talented local composer, Jesse Martin, to compose a special piece for the dedications of the Centennial Plaza. This ceremonial music was performed by a wind quartet at the dedication on September 7, 1997. The original music score was placed in the time capsule along with other artifacts. (Photograph courtesy of French Creek Development Association.)

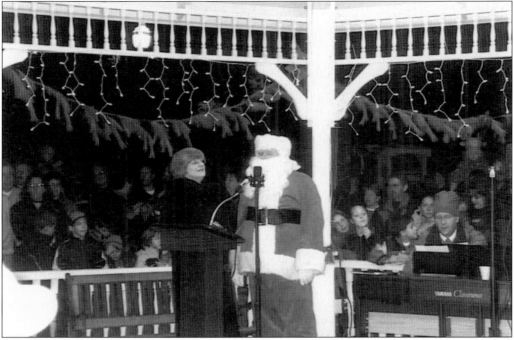

SANTA'S ANNUAL ARRIVAL. Santa addresses the children at the annual French Creek Christmas tree lighting. This annual event is sponsored by the French Creek Development Association, the Avon Historical Society, and the Lions Club. It is held at the gazebo at Heritage Square Park, and then Santa hands out presents at the Old Town Hall of 1871. (Photograph courtesy of French Creek Development Association.)

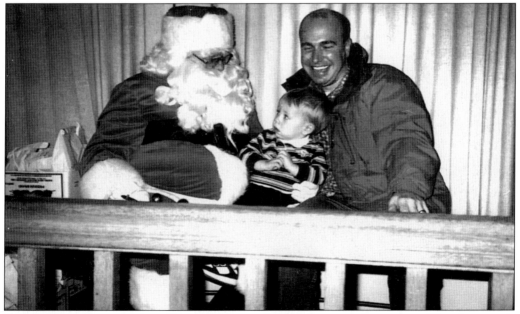

SANTA'S LIST. Santa is asking Tom Wible's son if he has been naughty or nice. The photograph was taken in the Old Town Hall of 1871 during the Christmas 2004 season. Santa has been visiting the children of Avon in the Old Town Hall for a long, long time.

AVON ISLE. Avon Isle was originally owned by Pierpont Edwards, a famous Revolutionary soldier, congressman, and Connecticut judge. The Knights of St. John were the first owners of the Dance Pavilion, the original name of the building built by F. J. Roth in 1926. It sits on a patch of land surrounded by the French Creek. In 1854, a channel was cut to increase water velocity for a nearby sawmill; thus an island was created. It flourished as a dance hall that attracted people from all of northeast Ohio. In later years, amateur and professional boxing matches, such as Golden Gloves, were held at the Avon Isle. Today, the city owns the property.

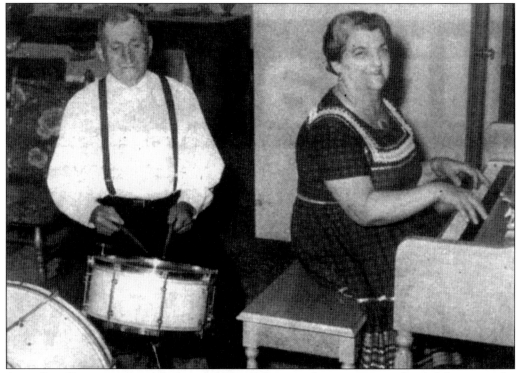

AVON ISLE ENTERTAINERS. George and Elsie Biltz were the entertainers that led dances at the Avon Isle for 18 years. They would play their music every Saturday night.

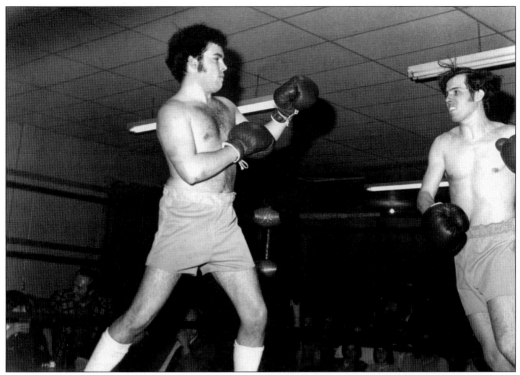

BOXING MATCH. Seen here in a boxing match at the Avon Isle are Marty Mangan (left) and James A. Smith, Avon's current mayor.

MOUND CEMETERY. Mound Cemetery is located at the corner of Route 83 (Center Road) and Route 254 (Detroit Road). Some people think that this site was originally an Indian burial mound. Most of Avon's first settlers and their descendants are buried at this cemetery.

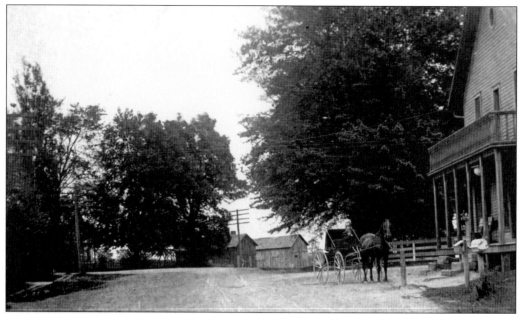

HENRY GREEN'S MARKET. This is a picture of the intersection of Center Road (Route 83) and Detroit Road. A wooden fence encloses the Mound Cemetery. The building on the southwest corner is Henry Green's market. The market sold feed. Many girls would have dresses made from the feed sacks. Today, Henry's would be in the middle of the road on Route 83.

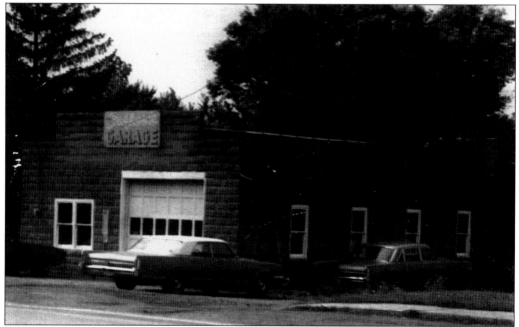

CASPER GARAGE. This concrete-block building is located on the east side of the Alten-Casper house (Tree House Gallery and Tea Room) at 36816 Detroit Road. The Avon Athletic Club baseball team of the 1920s practiced in the field where the garage would later stand. One of the players was Ed Casper, who built the garage in 1930 and became Avon's fire chief. Later the garage was operated by his son, Don Casper, who also became fire chief.

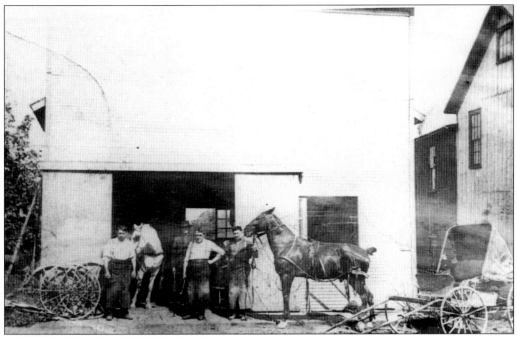

THE FURNITURE STORE. Here is one of the Wagners' buildings with the Wagners servicing a customer. At the establishment, many items such as wooden wheels were constructed for the horse and buggies.

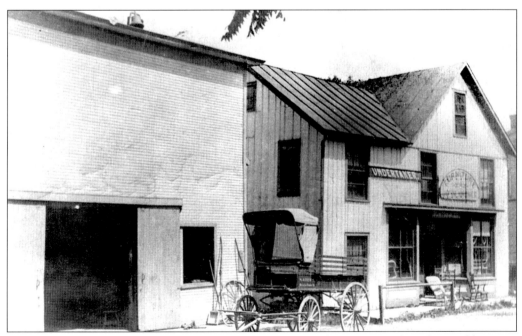

AVON'S UNDERTAKER. George Wagner was the owner of the furniture shop depicted here. As you can also see by the sign, George was also the town's undertaker. The buildings were located on the north side of Detroit Road.

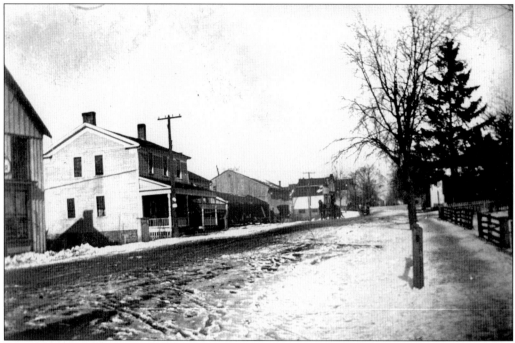

NORTH RIDGE ROAD. Continuing east down Detroit Road and next to the Wagner's furniture store was the town's second hotel. This view is looking east on Detroit Road, which was called North Ridge Road. The North Ridge was the shore of Lake Erie until about 5,000 years ago.

CORNER OF DETROIT AND COLORADO. This 1910 picture shows the corner of Detroit Road and Colorado Avenue/Stoney Ridge, looking east on Detroit Road. In front of the Old Town Hall is the water pump and well that local people used for their water supply. The stone porch of the Alten house is to the left.

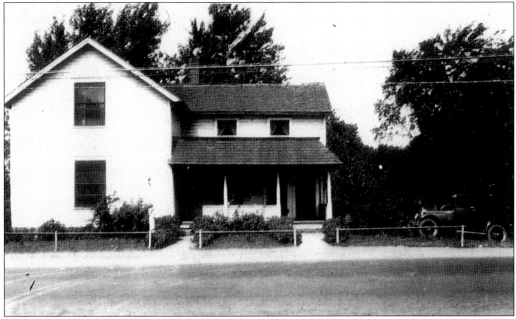

MEL'S TAVERN. Located on the north side of Detroit road during the 1930s was Mel's Sport Tavern. It was located in front of the Avon Isle sign area.

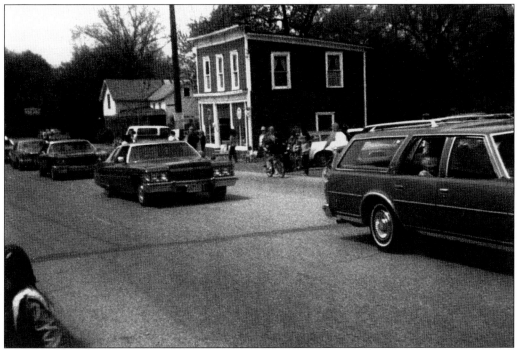

DETROIT ROAD NEAR AVON ISLE ENTRANCE. Here is a picture looking west down Detroit Road. The building in the forefront was originally part of the Weiler's department store. The store was then converted to many various stores, including a dry-cleaner, an antique store, and a television-repair shop. The building in the background was Mel's Sport Tavern. Between the two buildings is the Avon Isle driveway.

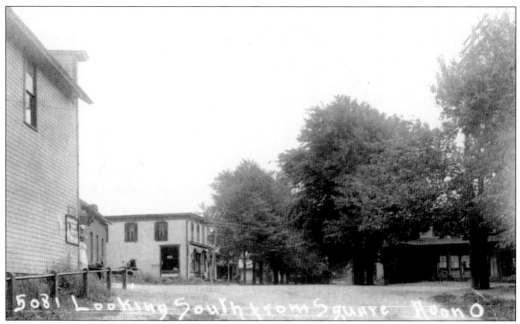

SOUTH ON COLORADO AVENUE. Here is a 1910 picture looking south on Colorado Avenue/Stoney Ridge and Detroit Roads. On the northeast corner is Leonard's Building, and the southeast corner is the side of the Old Town Hall. Today's gazebo at Heritage Square would be on the southwest corner (the right side of the picture).

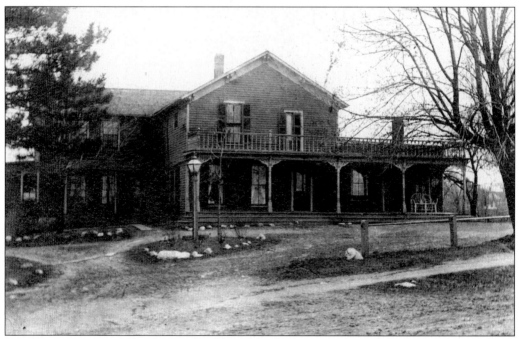

THE WILFORD HOTEL. Reuben Wilford built this home in 1850 and converted it to a hotel. It was a thriving business up until the 1950s. It was located on the south side of Detroit Road, west of the French Creek. Apartment buildings now reside on its location.

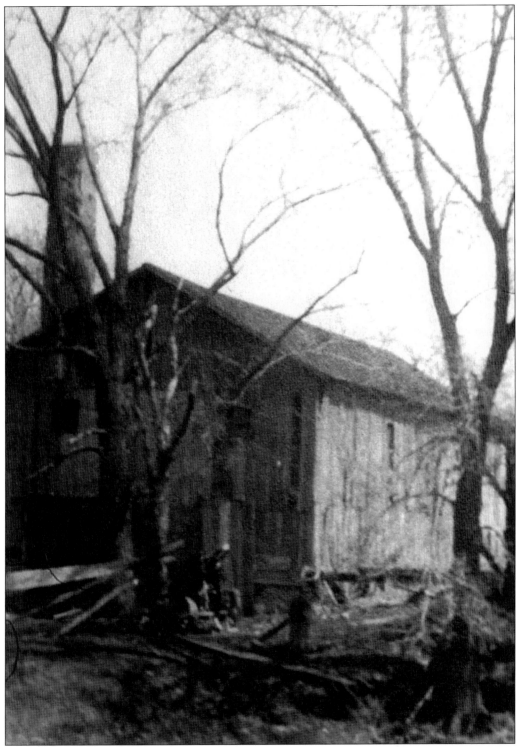

SAWMILL. Located on the north side of Detroit Road and near the Avon Isle was Avon's sawmill. The water from the French Creek helped power the mill.

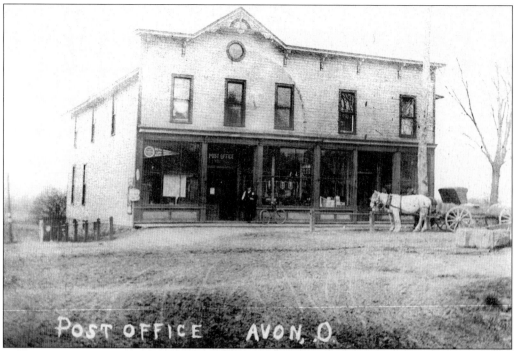

POST OFFICE. During the early 1900s, Avon's post office was located on the northeast corner of Detroit Road and Colorado Avenue.

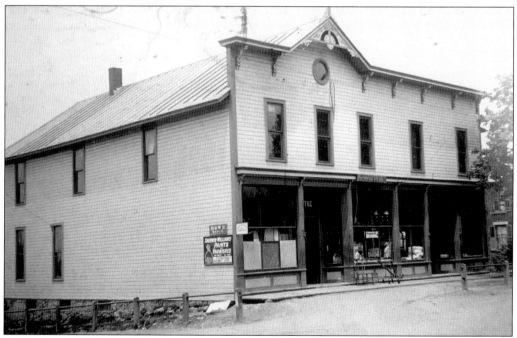

LEONARD'S. The post office was later converted into a hardware store called Leonard's. The store was also known, as locals say, as a general store called Martindale and Nye, Isadore Gelman (Izzie's) grocery store, and finally a Shell station. Now in the same location, there are no buildings, but a parking lot to a local fine restaurant housed in the Alten home.

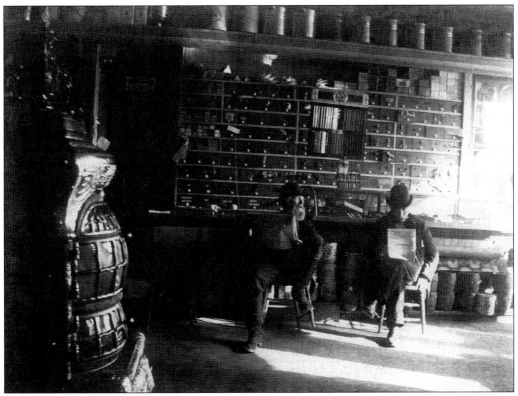

INSIDE LEONARD'S. Inside of Leonard's store was a regular meeting place. Word had it that there was good tobacco. Here are two men; one may be Mr. Cahoon.

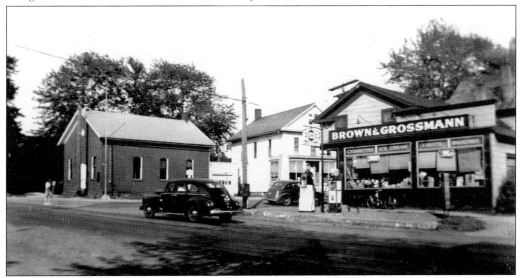

BROWN AND GROSSMANN. The Brown and Grossmann store was located on the southwest corner of Detroit and Stoney Ridge Roads. The Old Town Hall is in the background, and the barber shop is behind the Old Town Hall and single firehouse. The grocery store was in operation during the 1930s. Then it became Sam Falkenstein's, then a tavern, and finally the gazebo at Heritage Square Park. (Photograph courtesy of Robert Gates Sr.)

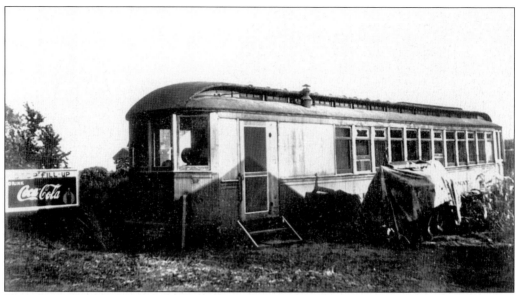

STREETCAR NO. 16. This retired Lakeshore Electric Railway car was moved to 34961 Detroit Road around 1938. It was used as a diner, gas station, and ice-cream stand. The car burned in November 1978. (Photograph courtesy of Alan Nagy.)

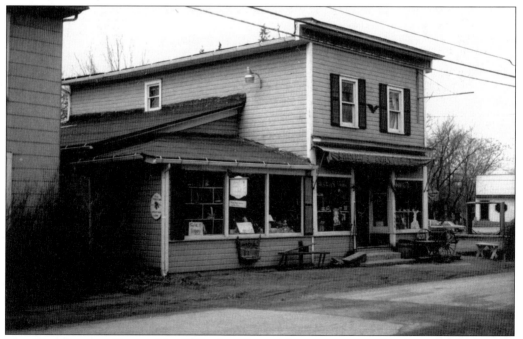

THE HAT SHOP OF TODAY. May Weber's millinery shop is now owned by Lois Shinko. Books, dollies, calico, and other antiques are sold in the store. The store is located on the west side of Stoney Ridge Road.

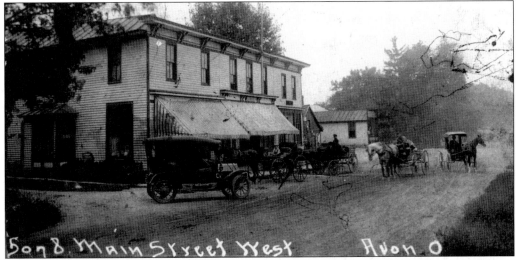

AVON'S DEPARTMENT STORE. Avon's department store was founded in 1892 by Joseph J. Weiler. The advertisement below mentions items sold in the store. Weiler was born in 1852 and came to Avon with his family at the age of six from LaGrange. When he retired, he turned the shop over to his sons-in-law, Lawrence Heckel and E. H. Klingshirn. (Photograph courtesy of Robert Gates Jr.)

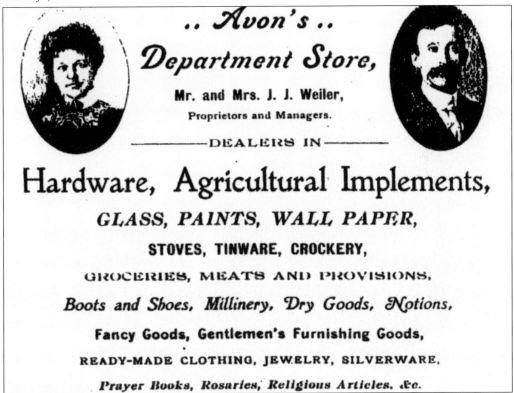

.. *Avon's* ..

Department Store,

Mr. and Mrs. J. J. Weiler,

Proprietors and Managers.

————— DEALERS IN —————

Hardware, Agricultural Implements,

GLASS, PAINTS, WALL PAPER,

STOVES, TINWARE, CROCKERY,

GROCERIES, MEATS AND PROVISIONS,

Boots and Shoes, Millinery, Dry Goods, Notions,

Fancy Goods, Gentlemen's Furnishing Goods,

READY-MADE CLOTHING, JEWELRY, SILVERWARE.

Prayer Books, Rosaries, Religious Articles. &c.

DEPARTMENT STORE ADVERTISEMENT. Here is an advertisement that appeared in the local paper advertising the goods that the owners Mr. and Mrs. Joseph Weiler sold. Joseph was born in 1852, and Mrs. Weiler was born in 1857. (Photograph courtesy of Janet Knight.)

71

BUCK'S HARDWARE. This was Avon's department store during the 1960s. It is now Buck's Hardware, located on the south side of Detroit Road west of Stoney Ridge Road.

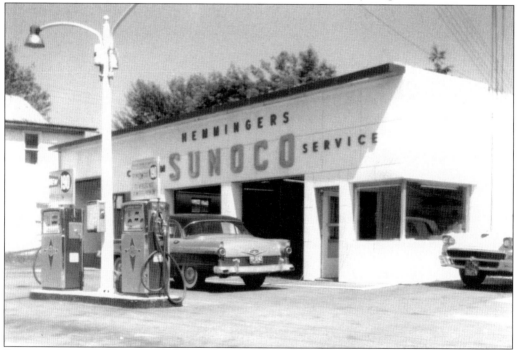

SUNOCO STATION. Hemminger's Sunoco was located between Buck's Hardware and Frank's Bar on the south side of Detroit Road just west of the intersection of Routes 611 and 254. Hemminger's was one of nine gas stations in town from the 1960s to the early 1970s. (Photograph courtesy of Bill Hemminger.)

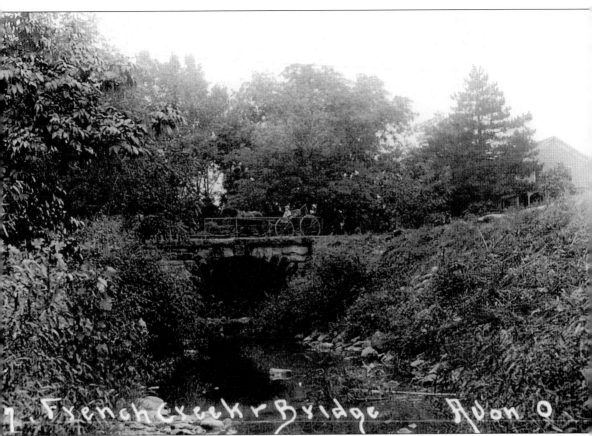

THE FRENCH CREEK BRIDGE. Here is a picture of the French Creek Bridge, looking south down the French Creek. To the right you can catch a glimpse of the Wilford Hotel. The bridge is part of Detroit Road. The photograph was taken in the early 1900s.

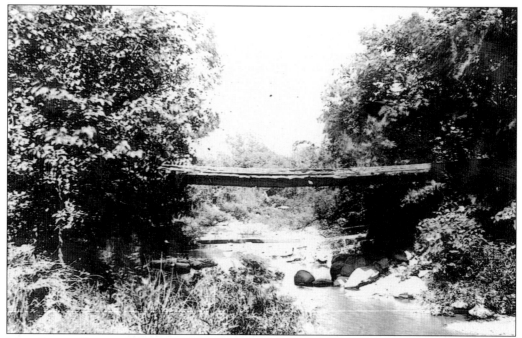

MILL STREET BRIDGE. The old Mill Street Bridge, located on the south side of Detroit Road, west of French Creek Road, and over the French Creek went to the Red Grist Mill. The foundation and abutments are still present. The bridge fell in the late 1940s. (Photograph courtesy of Ron Larson.)

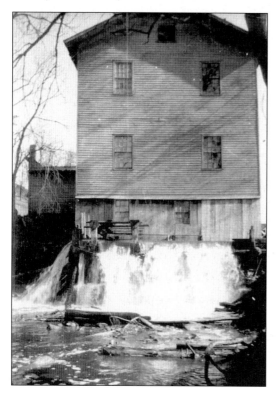

OLD FLOUR MILL. Behind St. Mary's Church, the Old Red Mill stood sentinel along French Creek. From its beginning in the late 1800s until it burned to the ground in the late 1950s, it was a good-sized mill that used to ship flour nationally. It was accessible by the wooden Mill Street Bridge.

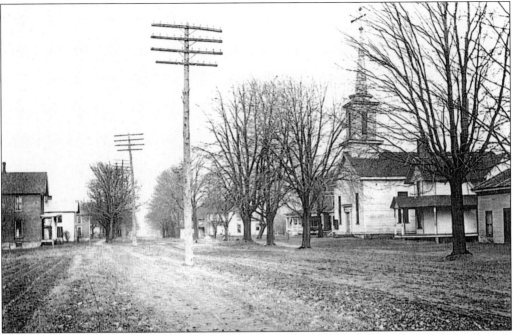

LOOKING EAST ON DETROIT ROAD. Here is a picture looking east on Detroit Road around 1910. The utility poles divided the road for the horse and buggy, as evidenced by the tracks shown in the picture. The church was the old Methodist church that burned in 1911.

HAYES STREET. Here is a view of Hayes Street, named for Pres. Rutherford B. Hayes at the time of the national centennial.

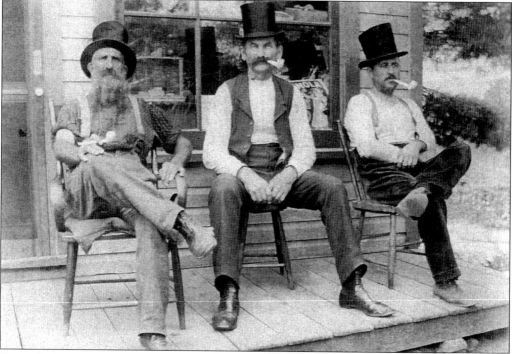

BROOK'S GENERAL STORE. Jim Brooks (left), Thom Warden (center), and George Wagner are shown sitting in front of the general store.

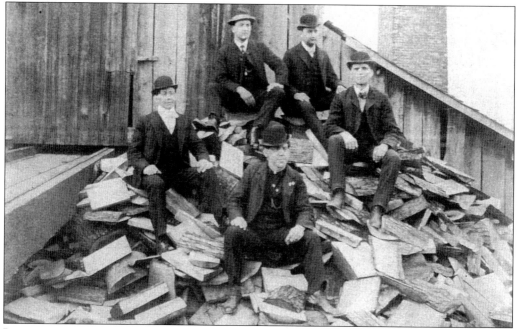

LUMBERYARD MEN. These men are taking a break at Avon's lumberyard in the late 1800s. They are Fred Lescher (front), Charlie Wilford (middle left), Billy Wilford (middle right), Lawrence Heckel (top left), and Joe Miller. The lumberyard was located on the north side of Detroit Road where the Briar Lakes subdivision is now located.

Four

SCHOOLS, CHURCHES, AND ORGANIZATIONS

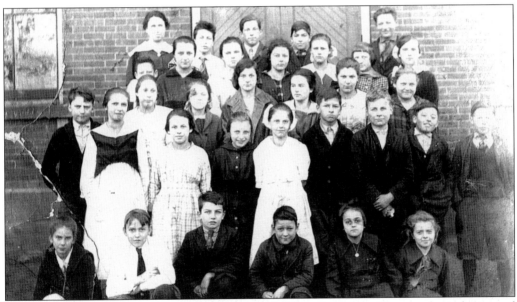

JULIAN STREET EIGHTH-GRADE STUDENTS, 1918. Julian School students are dressed prim and proper for this 1918 class picture. From left to right are (first row) unidentified, Lell Hubbard, Gene Hubbard, Delbert Wearsh, unidentified, and Catherine ?; (second row) Wilma Barrett, ? Miller, Margaret Wells, Laura Wilford, John Jamison, Loyd Wearsh, Paul Papay, and Hugo Gerhart; (third row) Edward Wilhelm, Caroline Gilbert, unidentified, Katherine Smith, Mildred Thompson, Ethal Thome, and Gracie Wearsh; (fourth row) Marion Barr, Olga Forthover, Georgine Miller, Jean Hancock, Stella Ackerman, Leota Kelbing, and Mildred Baldauf Horwedel; (fifth row) teacher Grace Reab, Erwin Fitch, Ed Riegelsberger, Lavern Henson, and Willie Papay. (Photograph courtesy of Debbie Chappo, granddaughter of Mildred Baldauf Horwedel.)

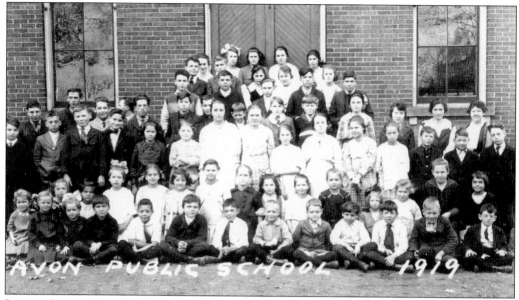

JULIAN STREET STUDENTS, 1919. Here is a class picture at the entrance to the Julian Street School. One member is identified as Catherine Harold, in the second row from the top. (Photograph courtesy of Jean McKitrick.)

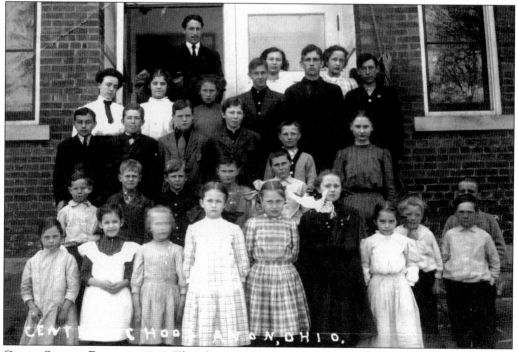

GRADE SCHOOL PICTURE, 1910. This photograph was taken at Center School on Detroit Road. The last boy on the right in the first row is John J. Harold. (Photograph courtesy of Jean McKitrick.)

NEW BOARD OFFICE HOME. The Kraker family home makes its way down Detroit Road during the early part of September 2003 to the grounds of Heritage Elementary School. The house will be converted into offices for the Avon Local Schools Board of Education. (Photograph courtesy of the Press, Julie A. Short.)

BUCKEYE BEAR OFF INTO SPACE. Adding an exciting dimension to learning, Avon East's third graders adopted a teddy bear to send around the world. Buckeye Bear served in three branches of the military: the army, air force, and navy. Before Buckeye Bear could retire, the students said that there was one place to which Buckeye had not traveled—outer space. With NASA, Buckeye flew on STS-103 to the Hubble Telescope. Another highlight of the year was meeting John Glenn of Ohio, the first American astronaut in orbit. (Photograph courtesy of Marcia Frank.)

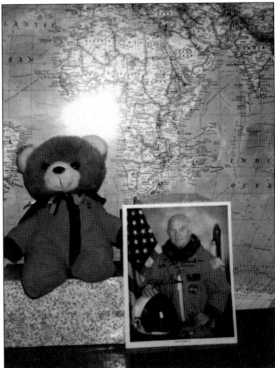

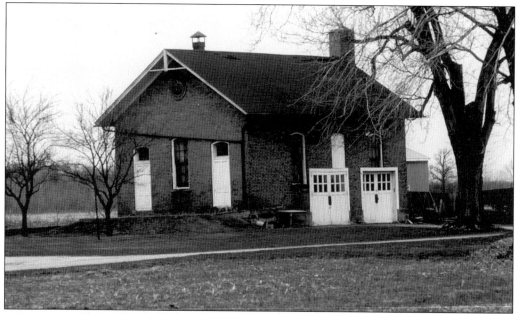

SCHOOLHOUSE ON MAYTON PROPERTY. Mayton School (*c.* 1875) is located across from 3815 Center Road. This brick schoolhouse has dark green chalkboards and a cupola for ventilation. Many bats now live in the big chimney. After the opening of the consolidated school, it was used as farm building to house the boiler for tomato hotbeds. The tomatoes were later planted in the open fields. In the summer, its three layers of brick provided cool storage for peppers.

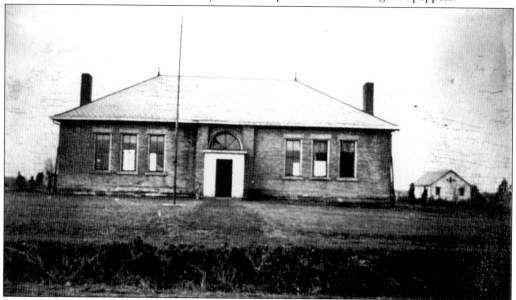

AVON CENTER SCHOOL. Built in 1910, the Avon Center School was located on the south side of Detroit Road. A central entranceway with a rounded window above is the focal point of this old schoolhouse, which has elements of both the Greek Revival and Italianate styles. It was converted to a residence after 1924, when the consolidated school (today the Village School) was built. The previous school on the same site (*c.* 1857) was moved north across Detroit Road to the Blackwell property and used as a slaughterhouse.

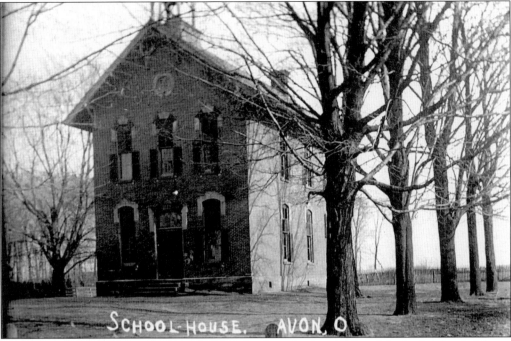

JULIAN STREET SCHOOL. The Julian Street School was built in 1880 and the high school addition was added in 1903. The school is remembered by the date plaque, rescued by Hugh Gough and embedded in the brick monument at the Village School. One legend is that Julian School was nicknamed Pig Tail Alley because of the girls with their pigtails going to school. Another legend is that the nickname came from the slaughterhouse on nearby Orchard Street.

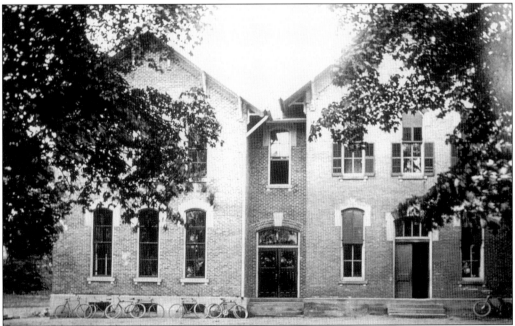

JULIAN STREET SCHOOL WITH HIGH SCHOOL. Here is a picture of the Julian Street School that was doubled in 1903 to house the high school students.

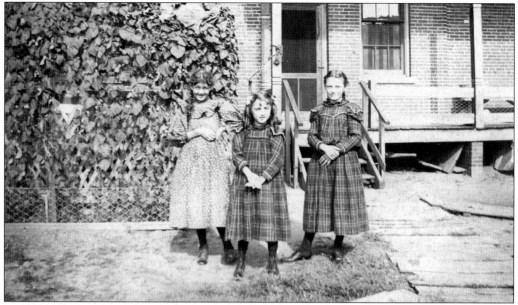

ST. MARY'S STUDENTS. Three girls pose outside St. Mary's School in 1895. From left to right are Theresa Wagner, Elizabeth Weiler Klingshirn, and Mary Weiler Heckel. (Photograph courtesy of Jean Fischer.)

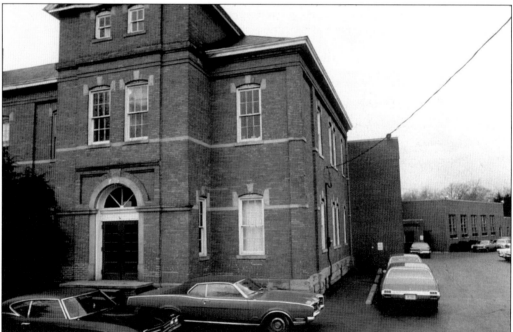

ST. MARY'S SCHOOL. St. Mary's was the first multiroom school in Avon and began in 1845. In 2005, the school celebrated the 120th anniversary of the 1885 building, which is visible from Stoney Ridge Road. The school's principal, Fr. Leo DeChant, said the school has modern technological features, such as building-wide wireless Internet capability. There are more than 20 laptops that can be taken throughout the building. Each classroom has at least two computers and is equipped with a television, a VCR, and a DVD player.

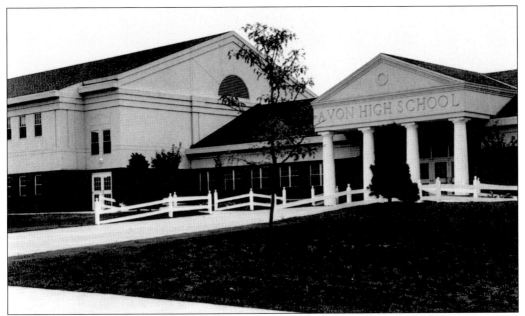

Avon High School. The current Avon High School was built and opened in 1998. McDonald, Bassett and Cassell designed the building. The school features a community auditorium. Many contributions came from public organizations and businesses and private citizens. It houses grades 9 through 12. (Photograph courtesy of Avon Local Schools.)

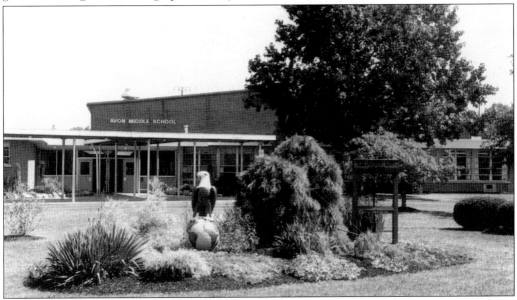

Avon Middle School. The building in which Avon Middle School is currently housed was constructed in 1956 as the district's high school. Additional classrooms were added in 1961. In 1988, grades seven and eight were moved from Avon Village School into the high school on Stoney Ridge Road, creating a 7th- through 12th-grade configuration. In 1998, a new district configuration was born on this site, creating grades six through eight. Since the completion of Heritage School in 2002, Avon Middle School was reconfigured back to grades seven and eight. (Photograph courtesy of Avon Local Schools.)

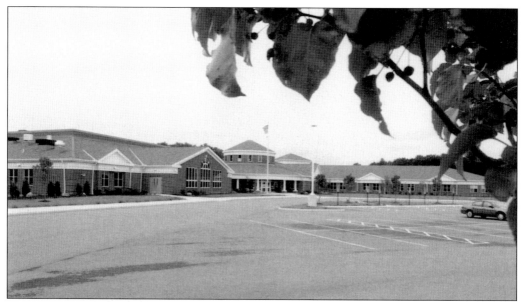

AVON HERITAGE ELEMENTARY SCHOOL. Located on the south side of Detroit at 35575 Detroit Road, it officially opened for the 2002 school year. It provides education to grades four through six. It was designed by Mansfield-based MKC Associates and totals 68,000 square feet. Heritage was selected by American School and University magazine for publication in the 2003 Architectural Portfolio honoring education design excellence. (Photograph courtesy of Avon Local Schools.)

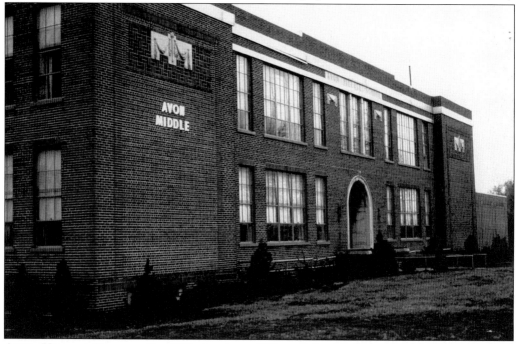

AVON VILLAGE SCHOOL. By 1930, the Avon Village School held grades 1 through 12. The consolidated school was made possible by the invention of the automobile for transportation and was considered an improvement over the one-room schoolhouse. (Photograph courtesy of Avon Local Schools.)

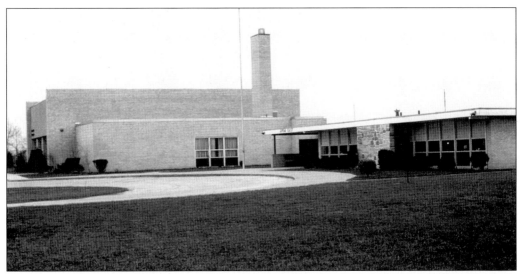

AVON EAST ELEMENTARY SCHOOL. The original building of Avon East was built in 1961. Early in the 1970s, the gymnasium, cafeteria, and kitchen were added. Until 1974, Avon East housed kindergarten through grade six. Sixth grade then became part of the junior high (now Avon Village). During the 1980s and 1990s, it hosted various grade levels. Commencing the 2002–2003 school year, Avon East was home to second and third grades. Major reconstruction continues, and it stands to double in size. It will house first and second grade. (Photograph courtesy of Avon Local Schools.)

HOLY TRINITY SCHOOL. Holy Trinity offers kindergarten through eighth grade. It is the oldest school in the Cleveland Catholic Diocese and even predates the diocese itself. The first church school was built at Nagel and Schwartz Roads as a one-room log cabin in 1845. An official dedication of new classrooms was held on September 11, 2005, with Bishop Robert Griese presiding. The new wing was dedicated to the Sisters of Notre Dame.

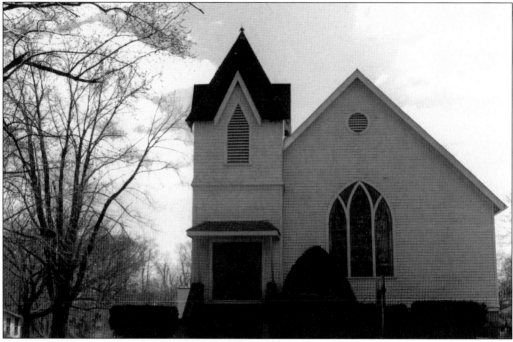

CHURCH OF GOD. This is the Methodist church that was built in 1911 after the previous church of 1855 burned. This building now houses the Church of God.

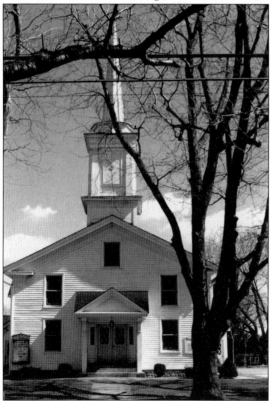

BAPTIST CHURCH. Avon Baptist Church, located at 2575 Stoney Ridge Road, was founded in 1817 by a small group of believers as a result of some meetings held in the home of Wilbur Cahoon. This small band of believers continued to meet and worship together in various places until around 1839, when the current property was purchased for $40 and the building that still stands as the sanctuary was constructed

METHODIST CHURCH, WOODEN. The Avon United Methodist Church was organized in 1820, meeting in a log schoolhouse until 1826 and served by circuit riders. The second building (constructed in 1855) burned down in January 1910, followed in 1911 by a new building, which housed the congregation until they adopted their current location at Detroit Road.

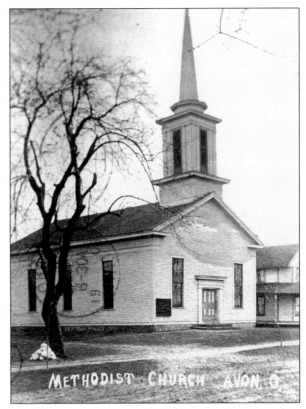

CHRISTIAN HERITAGE ASSEMBLY OF GOD. In November 1978, former pastor Rev. John M. Bunney, with 12 people from neighboring assemblies, founded the Christian Heritage Assembly of God Church. In 1979, their first building was located on the corner of Chester Road and Route 83, now Avon City Hall. Due to growth, the congregation was able to purchase an approximate 12-acre parcel for their first building. The first Sunday service was held in July 1997 at their new brick Colonial church, located at 36465 Chester Road.

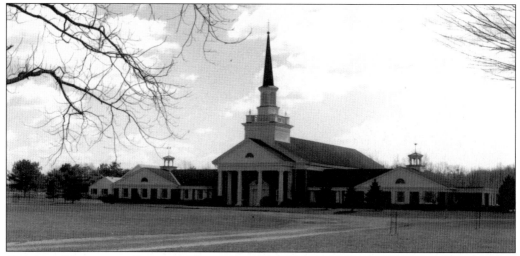

CURRENT METHODIST CHURCH. The current Avon United Methodist Church, built in 1965, is the congregation's fourth building. It stands on an 11-acre parcel, just west of Avon High School, at 37711 Detroit Road. Modern classrooms, a fellowship hall, and a beautiful courtyard were added in 2000. A barn and pavilion on the property are used for retreats and meetings by many community organizations. The pastor as of July 4, 2004, was Rev. Dr. David M. Oliver. Services provided include the Stephen Ministry and Parish Nurse Programs, Sunday school for all ages, nursery for babies and toddlers, small group ministries, and a very active quilt group.

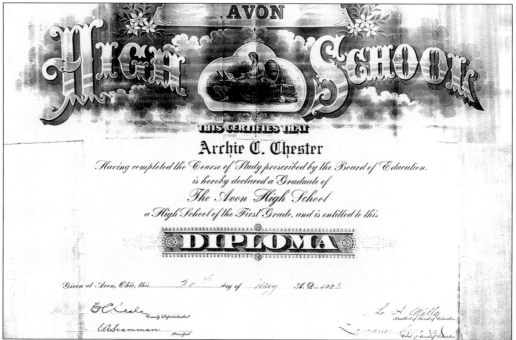

HIGH SCHOOL DIPLOMA. This diploma, dated May 1923, is that of Archie Chester, one of the grandchildren of Reuben Chester, for whom Chester Road is named. Reuben Chester came to Avon from Northamptonshire, England, in the mid-1800s. He was born in 1823, came to America in 1837 at the age of 14, and moved to Avon shortly after. He cleared 100 acres of land by hand. (Diploma courtesy of Donna Freshwater, great-granddaughter of Reuben Chester.)

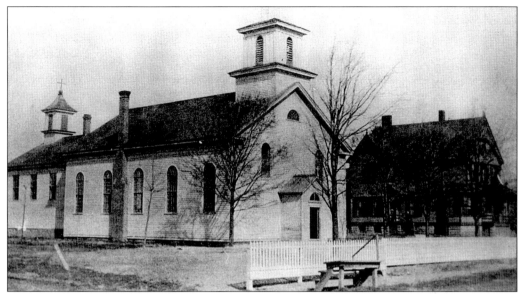

OLD HOLY TRINITY. Holy Trinity Church began in 1833, when a handful of Bavarian families arrived in Cleveland and then traveled westward into the woods beyond Rocky River to what is Avon today. More immigrants from Bavaria, Prussia, and the provinces of Alsace and Lorainne continued to arrive. The first mass in Lorain County was in the John Schwartz family cabin on March 21, 1841. Following their first church on Jaycox Road built in 1844, land was purchased in 1900 to build their present church located on Detroit Road.

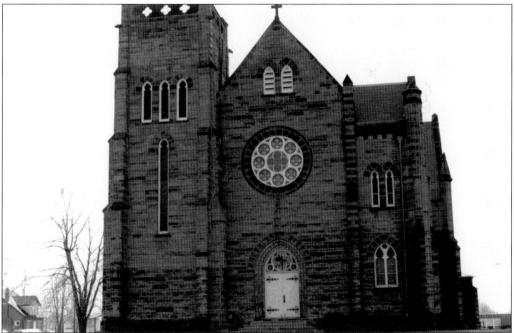

CURRENT HOLY TRINITY. Located at 33601 Detroit Road, Holy Trinity Church is constructed of 22,000 tons of sandstone from quarries in Amherst and Westlake. Their first mass in the "new" church was celebrated Christmas Eve 1902. Repairs were in order when in 1924 a tornado ravaged the area, damaging the church.

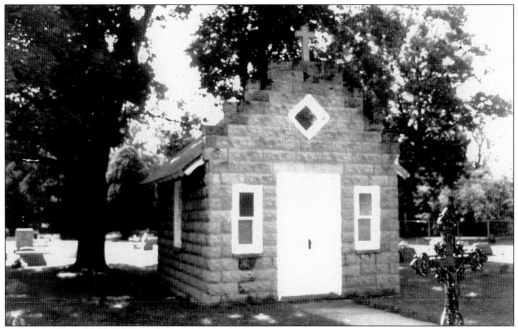

St. Mary's Cemetery Chapel. St. Mary's Cemetery Chapel is located at 2690 Stoney Ridge Road. This concrete-block, Colonial Revival–style chapel was built in 1914 by George Goetz III and his sons Cyril, Lawrence, and William Gates. Mr. and Mrs. Jacob Mohr visited Germany shortly before World War I. They were so grateful they were able to return safely to Avon that they donated the money for the chapel to be built. (Photograph courtesy of Robert Gates Jr.)

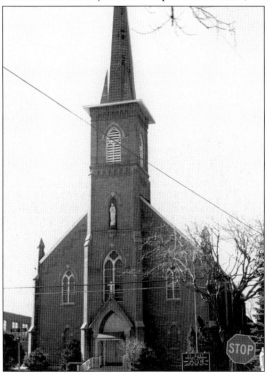

Current St. Mary's. After the congregation outgrew a frame church in 1849, a cornerstone was laid in May 1893 at 2640 Stoney Ridge Road. The new church was completed in 1895 without a dollar of debt to mar the joyous occasion. The approximate cost was $25,000. This church was considered to be one of the best appointed country churches in the Cleveland diocese at that time.

OLD ST. MARY'S. This is the first St. Mary of the Immaculate Conception Church building. In 1841, the first contingent of Catholic settlers arrived in the western part of Avon (or French Creek, as it was then called). For several years, they were identified with the congregations at Holy Trinity Church. In 1844, when the congregation numbered more than 50 families, the question of a site of a site of a church divided them. The Catholics at French Creek adopted a wagon shop as a temporary place of worship, creating the birth of St. Mary's Parish at French Creek.

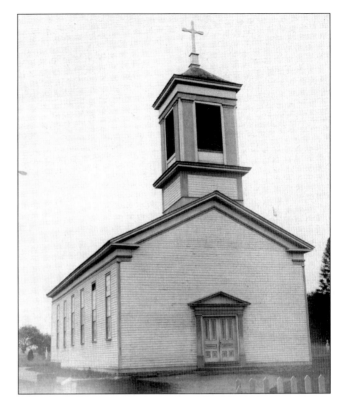

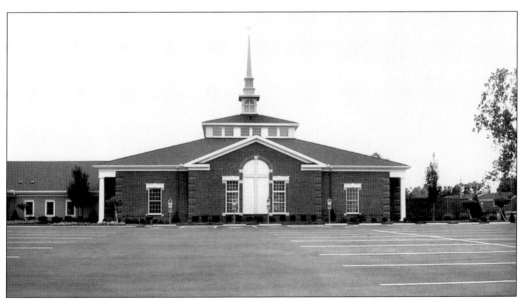

PROVIDENCE CHURCH. This church is affiliated with the Evangelical Free Church of America. In the summer of 1992, several families from the western communities of Greater Cleveland met to consider establishing a local church that would be founded on unchanging biblical truths yet would maintain relevant to the rapidly changing culture. Providence Church, located at 35295 Detroit Road, was completed in December 2003. The church's first pastor was Jim Bzdafka.

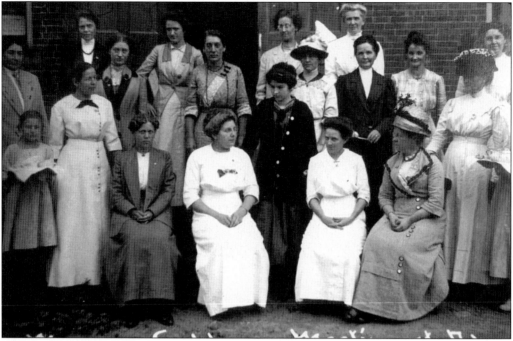

WOMAN'S SUFFRAGE. This is a picture of the first meeting of the woman's suffrage group of 1919 in front of either the Old Town Hall of 1871 or the Julian School. (Photograph courtesy of Mayor James A. Smith and Avon Historical Society.)

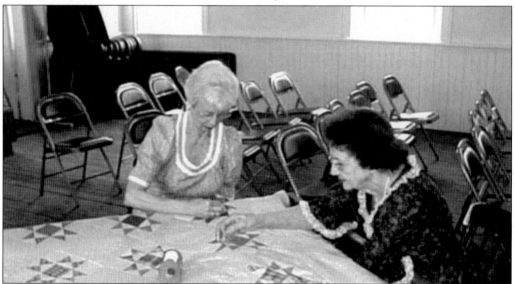

AVON HISTORICAL SOCIETY. The Avon Historical Society was formed in 1964, meeting in members' homes. Now they meet in the beautifully restored Old Town Hall of 1871. There have been four decades of achievement by the Avon Historical Society. Some include videos entitled *The Talking Quilt* and *The Avon Story* as well as various programs on Avon's history presented to Avon schools. All have the primary purpose of educating the public about historical events and places and preserving the heritage of Avon. Historical society members Pat Furnas (left) and Jean Fischer (right), dressed in Colonial costumes, continue to quilt at the Old Town Hall.

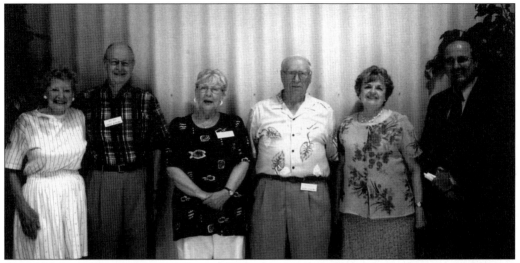

AVON SENIORS INCORPORATED. In mid-2001, the president of the Avon City Council, Shaun Brady, solicited community participations in looking to better serve the interests and needs of Avon senior citizens. Starting with a group of about a dozen people, it is now an organization of over 600 dues-paying members. The 2004–2005 officers are, from left to right, Shirley Saunders, Bob Fedor, Dianne Fisher, Bill Mayton, Helen Schatschneider, and Mayor James A. Smith. (Photograph courtesy of Helen Schatschneider.)

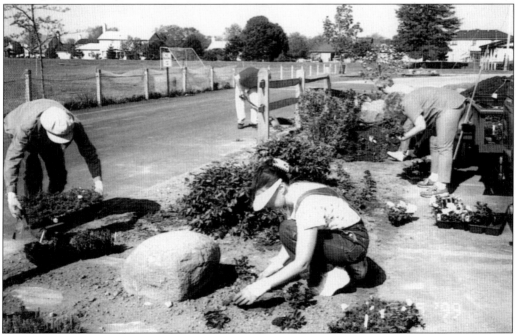

GARDEN CLUB. The garden club was established in the fall of 1995 with five founding members. Now the organization consists of 30 members. They conduct many community service projects, as seen in this picture. All around the city is evidence of hard work by the garden club. Since 2002, the club has donated butterfly kits to all Avon fourth-grade classrooms. On October 21, 2003, they held their first annual Avon Beautification Awards ceremony. (Photograph courtesy of Coletta Holowecky.)

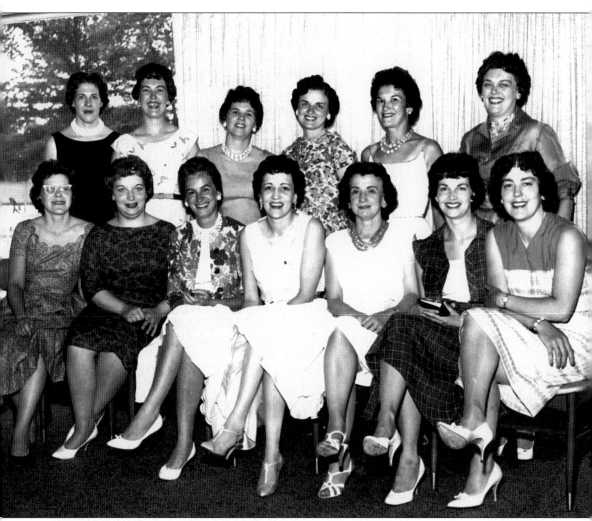

AVON WOMEN'S CLUB. The group was established in March 1949 as the first Avon Junior Woman's Club. They were incorporated in January 1957 and changed their status in September 1967 to Avon Women's Club. The group established and operated a kindergarten from 1953 to 1956, organized the first Memorial Day parade in 1954, published the first Avon Community Calendar, and began operating the first nursery school and first Adult Education Program from 1959 to 1969 and turned it over to the board of education. They continue to offer scholarships to students. The 1961–1962 members are, from left to right, as follows: (first row) Lois Cooper, Marlene Hall, Marty Hertl, Nancy Walker, Kay Hange, Annette Wenzel, and Doe Blair; (second row) Miriam Riegelsberger, Jeanne Cosner, Betty Williams, Helen Schatschneider, Marie Rak, and Ginny Fields. (Photograph courtesy of Helen Schatschneider.)

FRIENDS OF THE AVON LIBRARY.
This group was formed on January 31, 1956, for the purpose of providing additional funds to the new branch library to allow for programs such as summer reading, crafts, and other extra activities that would not otherwise be possible. Since then, they have been holding activities such as pet shows, paper drives, used-book sales, and yard sales to raise funds to aid the branch library in providing the residents of Avon with various extra activities.

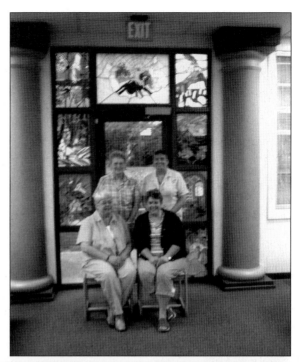

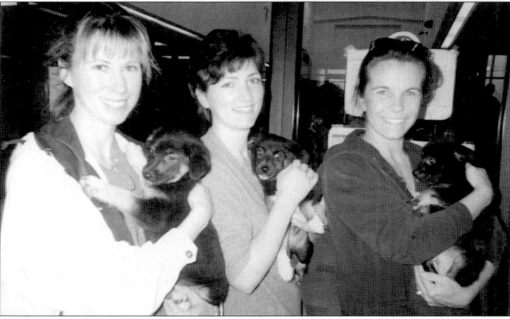

AVON JUNIOR WOMEN'S CLUB. The Avon Junior Women's Club was founded in September 1994 to bring together young women in Avon to work toward continuing to improve the community through charitable work and contributions. Each year, members organize several fundraising events allowing to make monetary donations to various community organizations and causes. Members volunteer their time at many agencies in Lorain County and surrounding vicinities. Here are members volunteering at an Animal Protective League. Additional information can be found at their Web site, http://www.ajwc.org. (Photograph courtesy of Avon Junior Women's Club.)

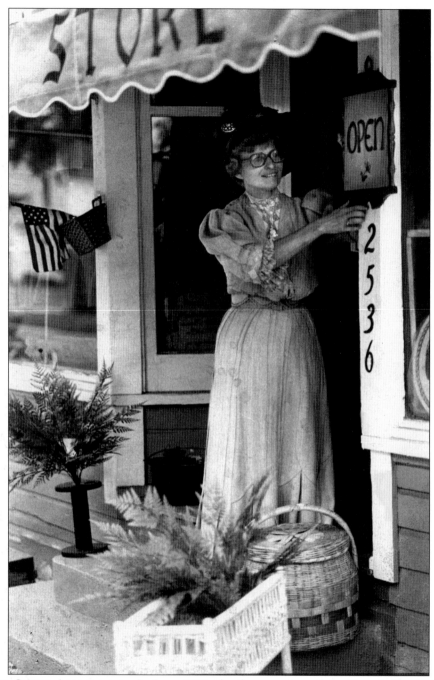

FRENCH CREEK ASSOCIATION. In June 1978, the first meeting of the French Creek Antique Association, spearheaded by Lois Shinko, was formed along with nine antique store owners. With the restoration of the many 1800s buildings being undertaken by the owners, craft and country stores have combined to further promote and restore the village of Avon back to the 1800s look. The French Creek Antique Association is now known as the French Creek Association, consisting of about 20 members. Lois Shinko is shown putting the Open sign out at one of her stores. (Photograph courtesy of Lois Shinko.)

Five

MUNICIPAL SERVICES

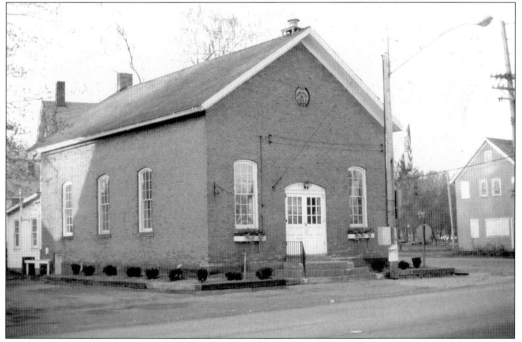

OLD TOWN HALL OF 1871. The land was purchased by Avon Township from Clemons Alten for $400. Bates and Dunning built the town hall in 1871 for $800. It was next owned by the Village of Avon (incorporated in 1917) and now by the City of Avon (1961). It housed the Avon Public Library starting in 1958. It became the home of the Avon Historical Society in 1977.

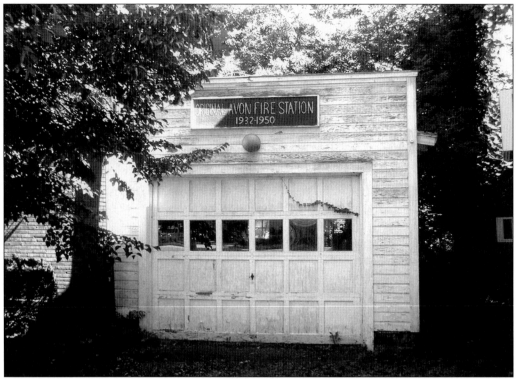

SINGLE FIRE STATION. A single-stall fire station was what served the village of Avon in 1950. It still stands behind the Old Town Hall on the east side of Stoney Ridge Road. It was operated by volunteer citizens for firemen.

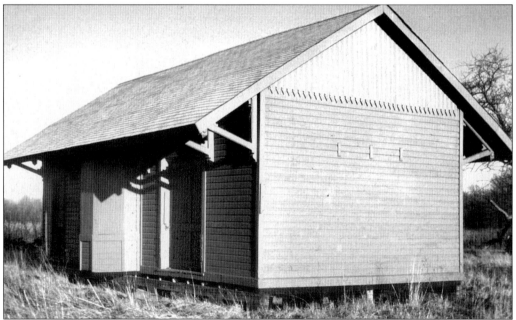

TRAIN STATION. The train station, once located on the railroad track between Avon and Avon Lake on Route 83, is now located in Olde Avon Village and rented out for retail.

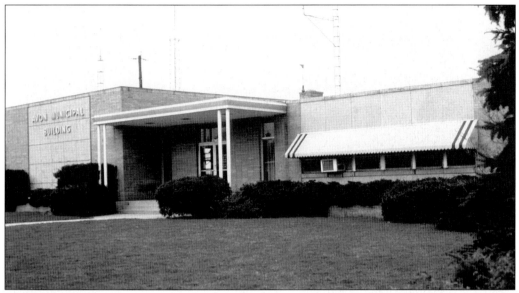

POLICE STATION. The police department, located at 36774 Detroit Road, now has a home of its own in the renovated building that once served as city hall and the police department for 40 years. In 1958, the building was dedicated by Lavern Pickering, the mayor at the time. The total cost of the building was about $90,000.

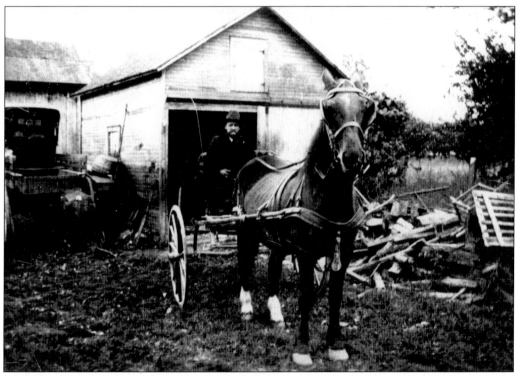

MARSHAL JOHN SMITH. Mayor James A. Smith is very proud of this photograph. Pictured around 1917 is John Smith, the mayor's grandfather. John Smith's term as marshal expired in 1921. (Photograph courtesy of Mayor James A. Smith.)

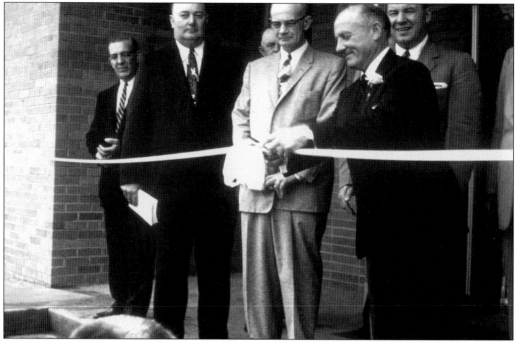

CITY HALL DEDICATION, 1958. On June 8, 1958, Mayor Lavern Pickering officially cuts the ribbon to dedicate the opening of the new Avon Municipal Building. At the dedication, the mayor said, "Your vote in the November 1958 election provided the funds." He added, "A vote of appreciation [goes] to Mr. and Mrs. Edward Mencl who exchanged property with the Village, permitting the driveway on the east side of the property."

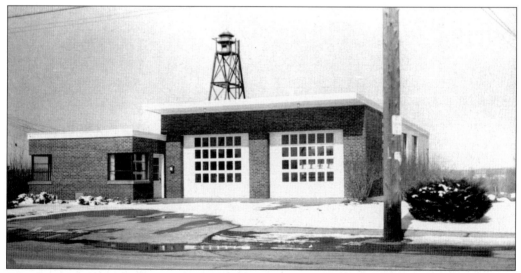

FIRE STATION NO. 1. Once located at 36784 Detroit Road, this building was one of two fire stations in Avon. In 2003, a new state-of-the-art building was erected at 36185 Detroit Road, and Fire Station No. 1 was closed. The building was not closed for long. In 2005, the building (after major renovations) became the Avon Senior Center.

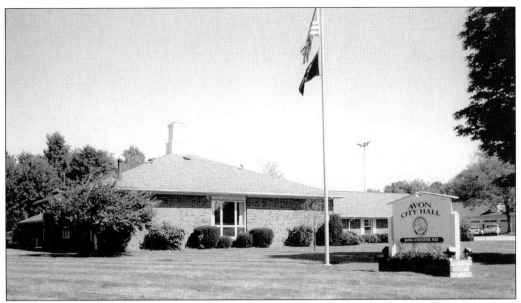

CURRENT CITY HALL. Located at a very busy intersection in Avon, 36080 Chester Road, the city hall moved into a former church building in 1998 because of its location and size, housing council chambers, the finance department, and planning commission and zoning offices. The building department is located in the basement of the building and is bursting at the seams due to the growing population and the number of new homes and businesses being constructed.

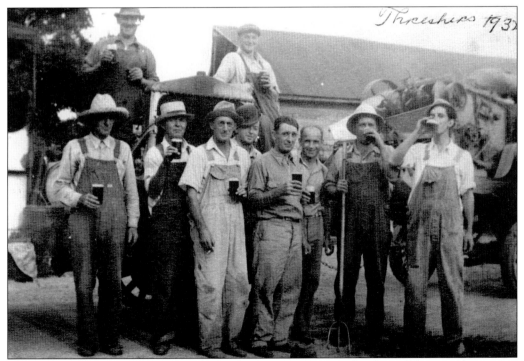

THRESHERS. These men, from the village of Avon in 1932, were threshers. (Photograph courtesy of Lois Shinko.)

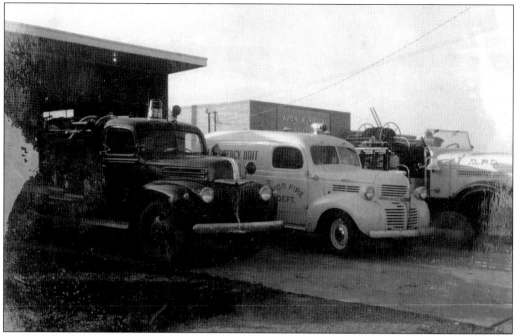

EMERGENCY VEHICLES. Avon's emergency vehicles are shown at the old fire station on Detroit Road in the late 1950s. (Photograph courtesy of the Gilles family.)

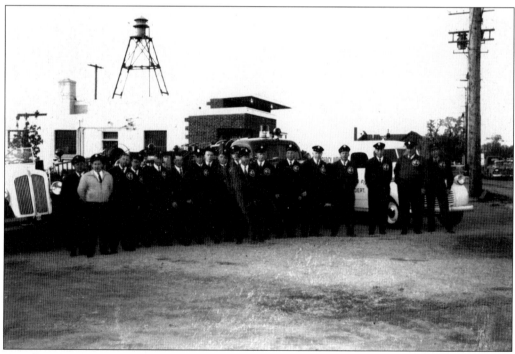

FIRE DEPARTMENT. Members of Avon's fire department and emergency team pose in 1958. In the background is the Detroit Road firehouse, which now houses a senior center. (Photograph courtesy of the Gilles family.)

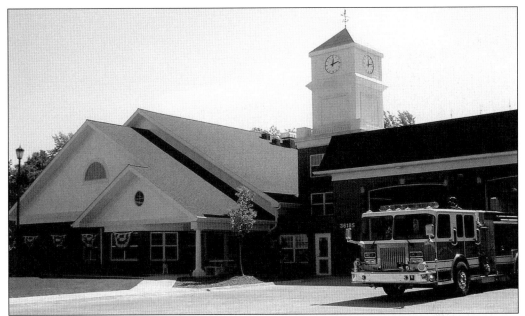

THE NEW FIRE DEPARTMENT. The fire department is now centrally located at 36185 Detroit Road (eliminating Fire Station No. 1, which was located farther west on Detroit Road) and is now the Avon Senior Center. This state-of-the-art building is a beautiful example of the Western Reserve architecture the city has deemed for the French Creek District. The building was fully operational in July 2003.

AVON PUBLIC LIBRARY. The Old Town Hall, located at the southeast corner of Stoney Ridge and Detroit Roads, was the first location of the library, which opened on November 4, 1956. The library moved to two different locations, 36931 Detroit Road and 2400 Ridgeland Drive, before it moved into this beautiful building at 37485 Harvest Drive on September 18, 1994.

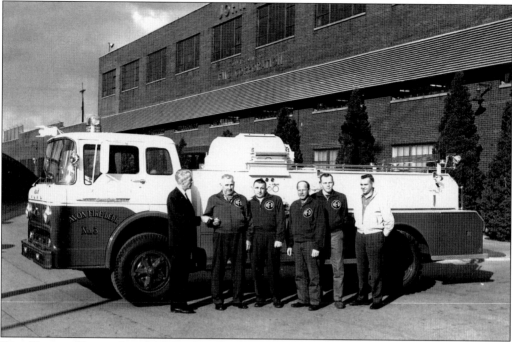

FIRE TRUCK. Here is fire chief Cyril Miller being presented with a new fire truck in the early 1970s. (Photograph courtesy of Lois Shinko.)

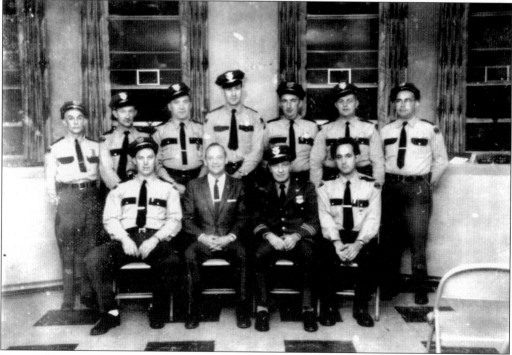

POLICE DEPARTMENT. In this group photograph, Chief Robert J. Gilles is seated in the front row, third from the left. He became the city's first full-time chief of police in 1954. (Photograph courtesy of the Gilles family.)

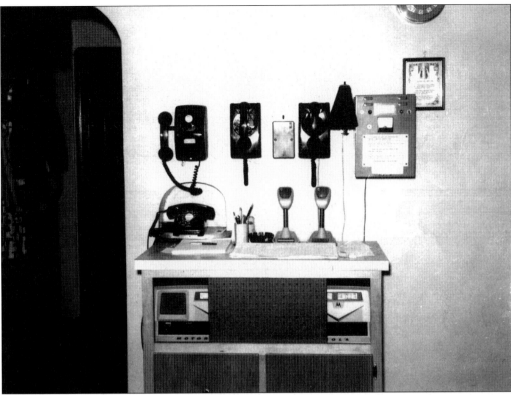

DISPATCH OFFICE. The kitchen of Chief Robert J. Gilles, in a house on Stoney Ridge, was the communications desk for police and fire emergency calls. This dispatch desk also had the alarm for the city bank. (Photograph courtesy of the Gilles family.)

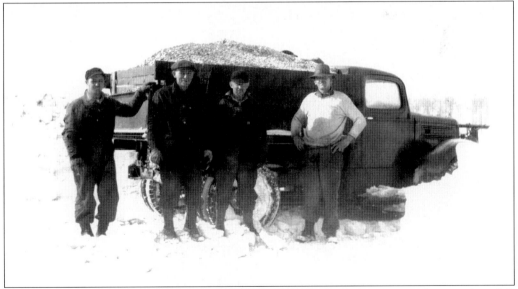

STREET DEPARTMENT. The members of the street department pose in 1944. They are, from left to right, Reynold Taddeo, Leo Smith, Donald Smith (son of Leo), and Tony Miller. (Photograph courtesy of JoAnn Albert.)

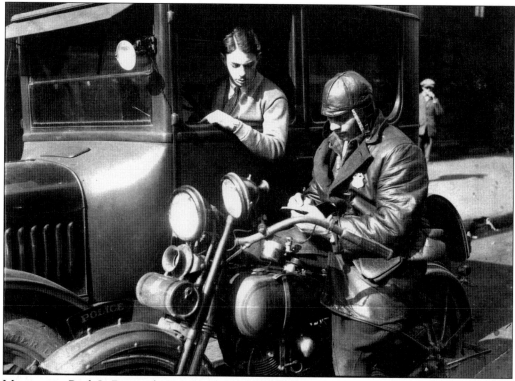

MARSHAL. Paul J. Dietz, shown giving out a ticket, became a marshal of Avon in 1931. (Photograph courtesy of Dorothy Newport, daughter of Paul Dietz.)

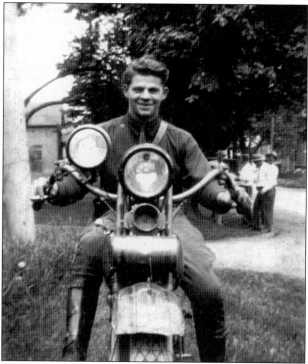

MOTORCYCLE POLICEMAN. Paul Dietz was a motorcycle policeman in the late 1920s. (Photograph courtesy of Dorothy Newport, daughter of Paul Dietz.)

Six

BUSINESSES

THE PICKERING FARM. Located at 35699 Detroit Road, this establishment started out as a tiny market stand in the 1940s. The current market is operated by the Pickerings' fourth generation. The market opens in the spring with strawberries grown on the farm and closes with season with homegrown pumpkins. In the fall, people of all ages enjoy going through the corn maze located behind the building. (Photograph courtesy of Karel Pickering.)

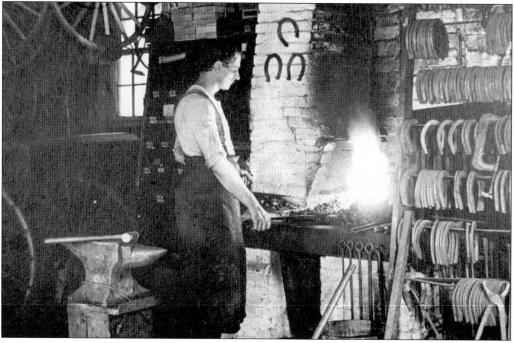

BLACKSMITH. John Wagner, pictured here, was one of two blacksmiths in Avon. Both were located on Detroit Road just west of the French Creek.

GRAPE HARVESTER. The climate provided by Lake Erie made vineyards practical in Avon. The grapes were harvested using this machine.

BLACKWELL BARN. The 1851 Blackwell Barn was relocated piece by piece from Fredericktown, Ohio, to Avon at the Olde Avon Village. The barn received the Community Rehabilitation Award in 2004 by the Lorain County Beautiful Award Program. The French Creek Development Association nominated the barn for this award. The barn is the new home to a textile shop.

KNIGHT'S GAS STATION. Once located at 36322 Detroit Road, this building was originally a gas station on the Knight property and then became a Sohio station, which closed in 1976. The building later became home to Monda Tire and Chem Clean. It was torn down in 1994. (Photograph courtesy of Alan Negy.)

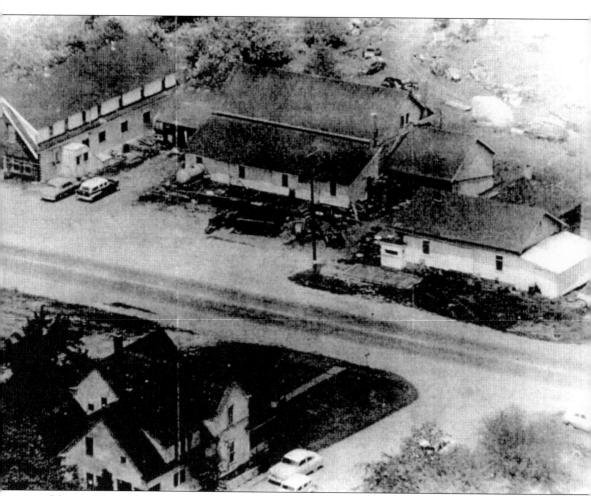

NAGEL WINERY. Pictured here is one of the 1930s wineries, Nagel Winery, located at Nagel and Detroit Roads. The winery press is the triangular building that later operated as a tavern up until the 1990s. The land is still farmed for vegetables today. (Photograph courtesy of Jean Fischer.)

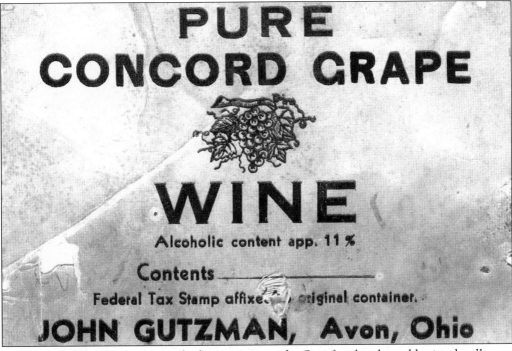

GUTZMAN WINE LABEL. Avon had many vineyards. One family who sold wine legally was that of John Gutzman. Here is a picture of the label from his vineyard. He sold wine from 1938 to 1944. Aloysius Nagel owned a press and would press grapes for John Gutzman. (Photograph courtesy of Joann C. Gutzman Albert.)

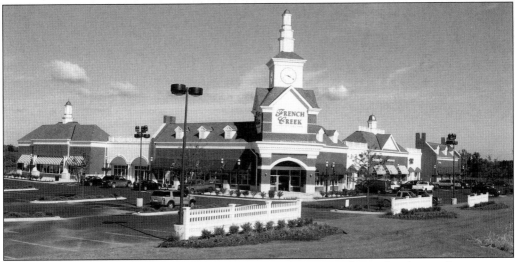

FRENCH CREEK SQUARE DEVELOPMENT. French Creek Square is located at the northwest corner of Route 83 and Detroit Road and symbolizes a gateway into Avon's French Creek District. Designed in the Western Reserve architectural style, each element of the building consists of external varying wall contours capped by varying roof levels. The materials used are similar to many of those found in the ageless style of Avon's original buildings. The signature clock tower, central to the design of French Creek Square, serves as a reference point and a beacon of light for the community. (Photograph courtesy of Lisa Dove at Zeisler-Morgan.)

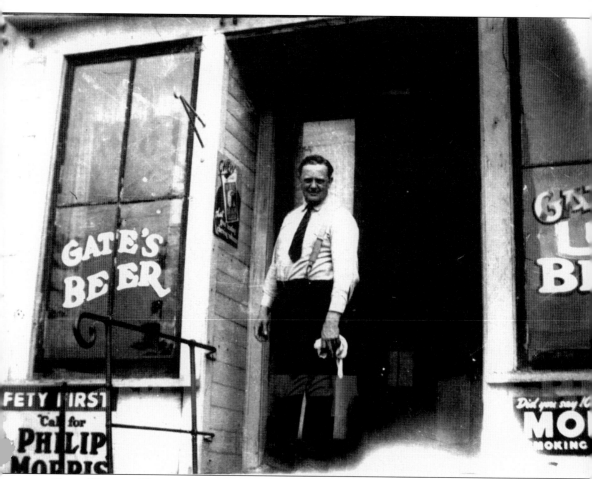

GATES' LUNCH. This is a picture in front of French Creek Tavern, located at the corner of Routes 611 and 254. Cyril Gates (pictured) and Frank Miller ran the tavern from 1925 to 1942. In 1919, laws were passed making it illegal to sell alcohol. No longer a tavern, it was named Gates' Lunch. Cyril was known to have good lunch food throughout the area, but if he knew you and if you asked, under the counter was a pint of whisky for refreshments; thus it was also a speakeasy. The government suspected alcohol was being sold, so one day a car pulled up and six men in suits got out. Knowing they were not there for lunch, Cyril gave the bottle to a friend, Deppy Miler, and told him to run. Running across the creek and Avon Isle with men chasing him, Deppy lost the men, hiding in his family farm just west of the Isle. The men, having no alcohol evidence, got back in their car and went back to Cleveland. The word *beer* was added to the window sign after Prohibition was repealed in 1933. (Photograph courtesy of Robert Gates Sr. and Robert Gates Jr.)

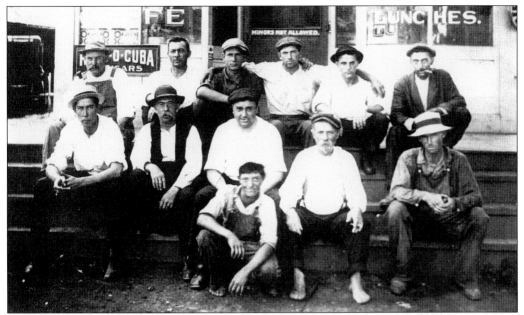

BARBIER'S TAVERN. Barbier's Tavern, now Frank and Ellie's, was located on the south side of Detroit Road, just east of French Creek Road. From left to right are (first row) Ed Casper (kneeling), Jacob Mohn, and Mr. Walters; (second row) Elmer Frank, Frank Gates, and Linus Tomlin; (third row) unidentified, Nick Casper, Julius Barbier, Philip DeChant, Stup Carpenter, and unidentified.

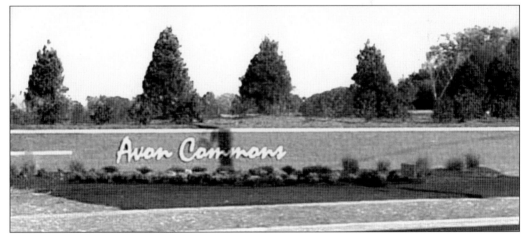

AVON COMMONS. Avon Commons is located on the north side of Detroit Road, east of Route 83 and south of Interstate 90. It is a shopping center development on 100 acres. The center is beautifully landscaped and has a walking path throughout the development. A landscape mound at the entrance provides green space and privacy with no buildings visible from the road. The shopping center has numerous nationally recognized stores as well as restaurants. (Photograph courtesy of Taylor J. Smith.)

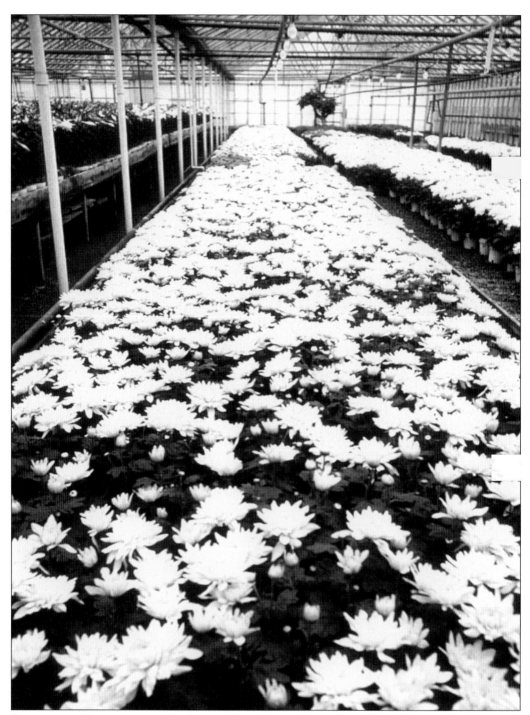

PINEHAVEN GREENHOUSE. Pinehaven Greenhouse, located at 39424 Detroit Road, started as a small part-time hobby for Niels and Sally Jensen. In the winter of 1985, they bought an acre greenhouse on a 10-acre lot. Since then, Bryan and Bruce Jensen have entered the family business. In the last 13 years, they have added many new greenhouses. They grow about 65,000 annual flats (2.7 million seedlings) and grow 30,000 garden mums and 50,000 poinsettias.

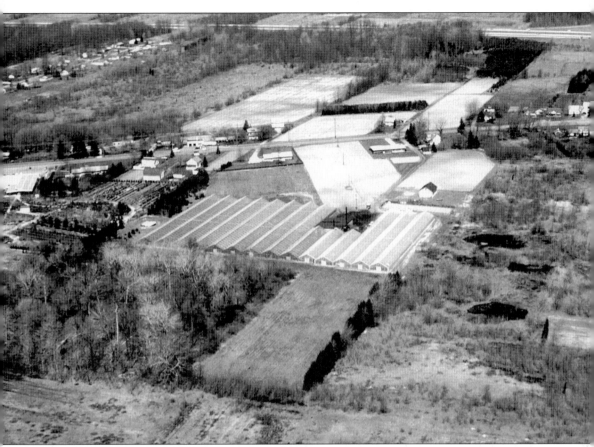

AERIAL PHOTOGRAPH OF GREENHOUSES. Much of Avon's land was used for farming or vineyard. Purchasing tomatoes from Mexico was just unheard of. As seen in this picture, many greenhouses were visible throughout the countryside.

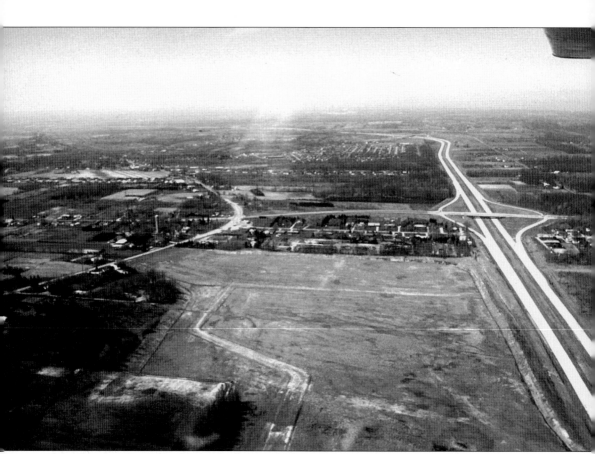

AERIAL SHOT, 1974. This aerial view looks west toward the Interstate 90 and Route 83 interchange. The vacant land is where the Avon Commons Shopping Center now stands.

Seven

Recreational Places, Activities, and Disasters

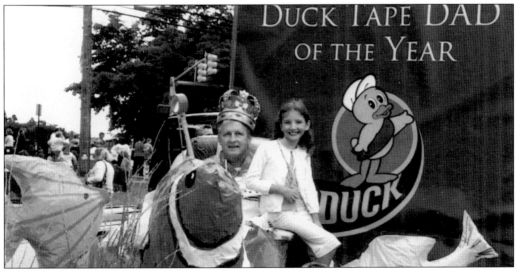

Duct Tape King Dad. Veteran's Memorial Park opened in April 2003. The park is located at 37001 Detroit Road and features three Little League baseball fields, a Thurman Munson baseball field, two softball fields, and two soccer fields. The park also features a concession stand for patrons. Henkel Consumer Adhesives held the first annual International Duct Tape Festival on Father's Day weekend in 2004 at the park. Steve Harris was crowned the first Duct Tape King Dad. His seven-year-old daughter wrote an essay on why her dad is the king. (Photograph courtesy of the Harris family.)

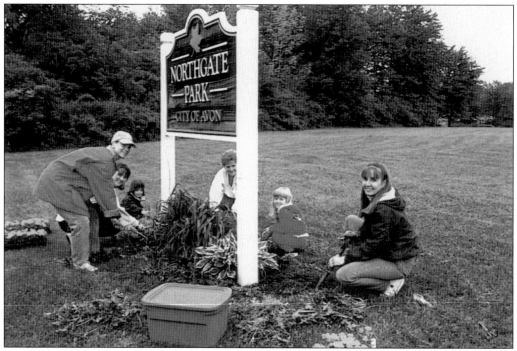

NORTHGATE PARK ENTRANCE. Northgate Community Park is located off Colorado Avenue at 2155 Eaton Drive in the Northgate development in Avon. This park features an outdoor walking and fitness track, playground facilities, pavilion with grills and picnic tables, open green space for flag football and soccer games, and a fishing pond. A sled-riding hill is available during the winter months. (Photograph courtesy of Lauren Davis.)

SCHWARTZ PARK. The Avon community park is located at 34741 Schwartz Road in East Avon. This park features two baseball or softball fields, multiple soccer fields, playground facilities, and a pavilion with tables and grills available for rental. The park also features a sand volleyball court and an outdoor winter ice-skating pond.

LIONS COMMUNITY CENTER. The Avon Community Center was built in the early 1960s and was used as a teen center. Teens utilized the ice-skating rink and outdoor pool in the Northgate development. The center closed a few years later and was used as a storage facility for the city. The Avon Lions Club renovated the building and renamed it the Lions Club Community Center. Local organizations and residents now use the center for meetings and social gathering.

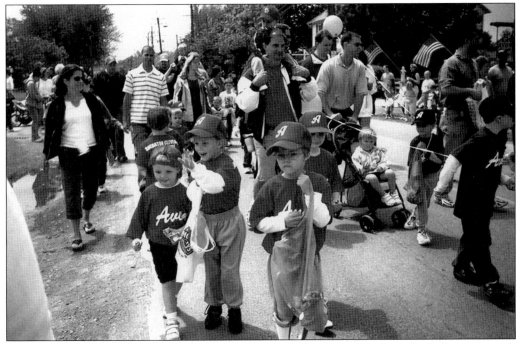

LITTLE LEAGUE PARADE. Hundreds of players and coaches from the Avon Little League march through the streets of Avon. This is an annual event for the opening ceremonies. In 2004, more than 900 boys and girls participated in the program. (Photograph courtesy of the Press, Julie A. Short.)

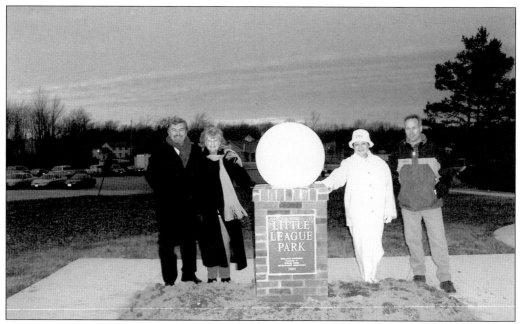

LITTLE LEAGUE PARK DEDICATION. December 4, 2004, was the dedication of the entrance to the Little League Park located on the north side of Detroit behind the police station. The monument entrance was constructed by the French Creek Development Association. Pictured above, from left to right, are Paul Burik, Carol Hartwig, Joanne Easterday, and Craig Furnas. (Photograph courtesy of the Press, Julie A. Short.)

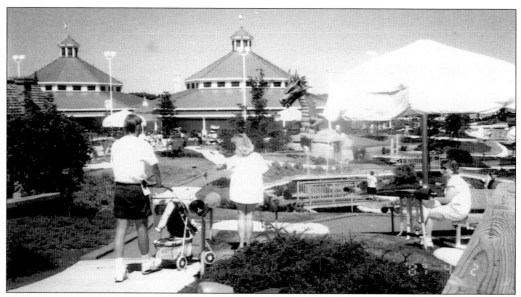

GOODTIMES. Goodtimes was built in 1993 on 12 acres of land located off Interstate 90 at 33777 Chester Road in Avon. The fun park features go-karts, miniature golf, laser tag, paddleboats, bumper boats, paintball, and an arcade. Goodtimes is a great place for children's birthday parties, family reunions, church outings, school field trips, and company picnics. The outdoor picnic area, Caterville, can accommodate up to 500 guests. (Photograph courtesy of Lauren Davis.)

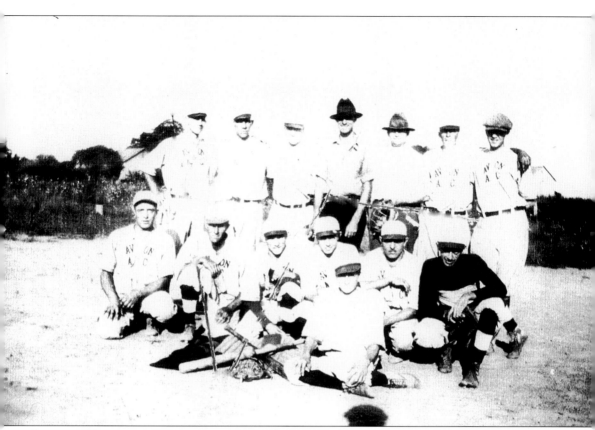

BASEBALL TEAM, 1921. From 1921 to 1925, the Avon Athletic Club baseball team practiced in the field behind the former Casper's garage, next to the police station. This field is now the Little League Park. From left to right are (first row) Edward Casper, Clarence Casper (first coach), four unidentified men, and Urban Casper; (second row) Herber Knipper, Carl Smith, Jack Rehm, Walter DeChant, Steve Alten, George Alten, and an unidentified man.

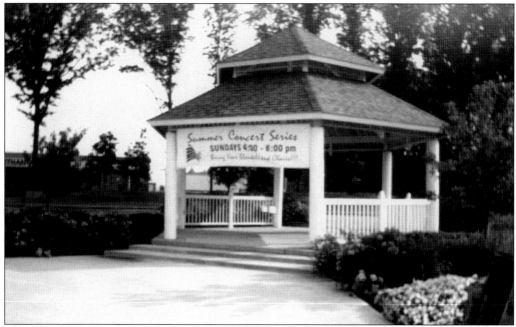

BARNHART GAZEBO. The Robert Barnhart Gazebo is located between the Avenbury Lakes Development and Avon Commons. Summer concerts and car shows are held on the weekends during the summer months. This gazebo was opened on June 24, 2001.

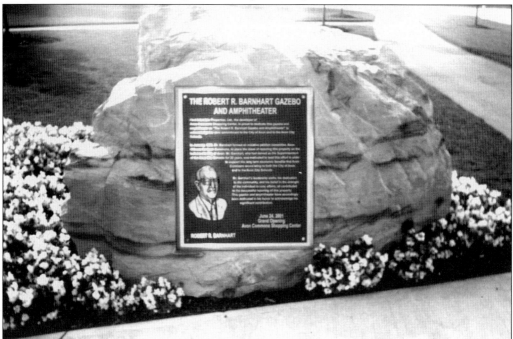

BARNHART ROCK. On June 24, 2001, a gazebo and amphitheater were dedicated to acknowledge Robert R. Barnhart's civic commitment to the city of Avon and to the Avon City Schools. In 1999, Barnhart formed an initiative petition committee to place a zoning approval on the ballot, which would allow the Avon Commons Shopping Center to be built.

OUTHOUSE RACES DURING FESTIVAL OF FLOWERS. The great Avon Outhouse Race is history. On a bright Sunday afternoon, eight outhouses were pushed down the street. Four guys wearing devilishly worded sweatshirts won $100, and a police car was nearly rammed as hundred of spectators cheered the race. Runners Dan Holowecky, David Morahan, Gary Nagel, and Brian Holowecky (driving) near the finish line to win their division in the first annual French Creek Outhouse Race in Avon. (Photograph courtesy of Lois Shinko.)

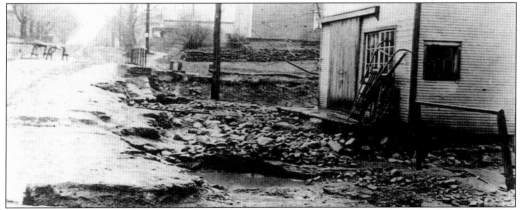

WINTER, 1912–1913. This picture was taken in front of Charlie Wagner's blacksmith shop, looking west to the creek bridge. The winter was a particularly bad one for the entire Great Lakes region. By winter's end, large quantities of snow had fallen and not melted. In early spring, temperatures rapidly warmed up and it rained hard, which caused the flood. (Photograph courtesy of Robert Gates Jr.)

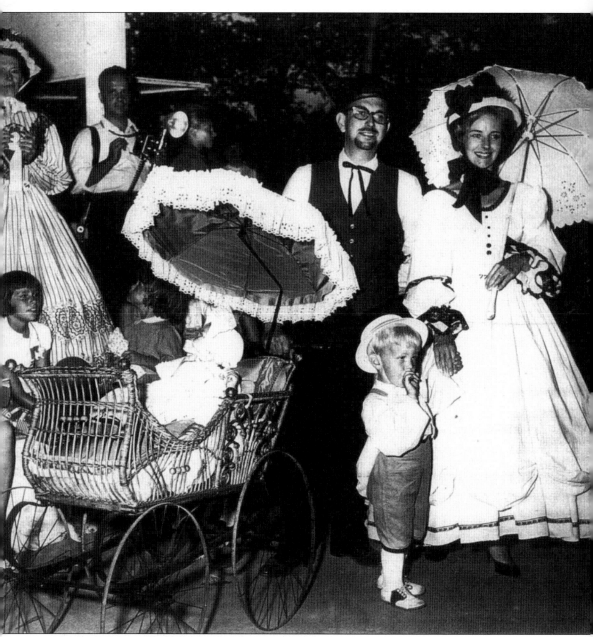

SESQUICENTENNIAL FAMILY PORTRAIT, 1964. A celebration was held on September 7, 1964, at the Avon Isle to mark Avon's 150th birthday. The festivities included a costume contest to see who could dress accordingly to the times. The blue ribbon went to the Joseph Richvalsky family. Every detail of their costume was correct, right down to the antique baby carriage. Pictured from left to right are (first row) an unidentified girl, Ann Richvalsky (in the buggy), and Steven Richvalsky (standing next to the buggy); (second row) Jo Demaline, Jack Graaf, Joe Richvalsky, and Eileen Richvalsky. (Photograph courtesy of Joseph Richvalsky.)

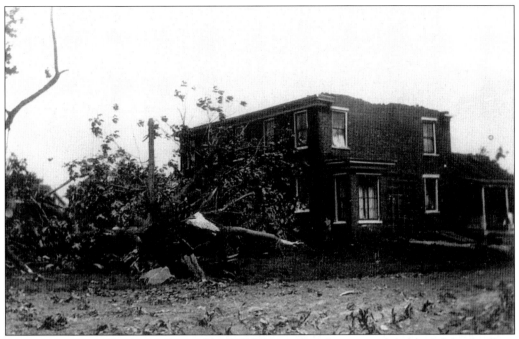

TORNADO, 1924. This house, located at 35676 Detroit Road, was struck by one of the deadliest tornados in Ohio on Saturday, June 28, 1924. Leonard Piazza remembered that his family was eating in the kitchen when the tornado hit.

TORNADO, 1953. On June 8, 1953, another tornado destroyed homes in Avon. Here is a picture of a home at 4606 Case Road damaged by the tornado.

AVON JAYCEES

THE

**BARNSTORMIN'
BARNHILLS**

FLYING CIRCUS

BOSWORTH AIRPORT
Aug. 8 & 9

COMEDY FLYING
PARACHUTING

TAILSKID

ANTIQUE AIRPLANE RIDES

REFRESHMENTS

in person TV.
JUNGLE·LARRY

WILD ANIMAL CIRCUS

BIG
CATS

EXOTIC
REPTILES

DARING EXCITING FUN

AVON, OHIO

THE AVON JAYCEES AIR OLYMPICS. The Avon Jaycees Air Olympics were held at Avon's Bosworth Airport (also known as Mather Airport), located on Nagel Road where Red Tail is today, during 1964, 1965, and 1966. These air shows included the Barnstormin' Barnhills Flying Circus. Barnhills had three antique airplanes, two Boeing Stearman, and a Ryan open-cockpit monoplane and performed aerial acrobatics. Dean Ortner flew his P-51 Mustang and a J-2 Piper trainer, which he flew backwards into a mild headwind. About a dozen parachutists took off and had spectacular jumps. Arlo Mather, operator of the airport, did a clown act with his Piper Cub. John Eldred arranged for the first return of air races to the Cleveland area. Among other highlights of the publicity was *The Adventures of Chicken Hawk* (directed by and starring Ted Beckman), which played on the Ghoulardi Show. In the last air show, Goodyear-Midget style racing airplanes were brought in and staged an air race circling pylons erected in nearby farmland. (Photograph courtesy of John Eldred.)

BOXER. In the late 1920s and early 1930s, Paul Dietz was a championship boxer. He might have boxed at the Avon Isle. Paul was a police officer and later marshal for the town of Avon. (Photograph courtesy of Dorothy Newport, daughter of Paul Dietz.)

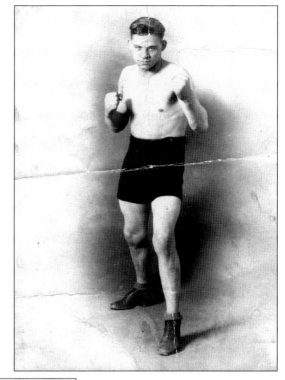

FESTIVAL OF FLOWERS, GIANT SLIDE. Avon had many activities that occurred during the celebration of Festival of Flowers. Here is Julie Kozminski on the giant slide. (Photograph courtesy of the Littell family.)

DUCT TAPE DOG. During the Duct Tape Parade, many participants were very creative in the usage of duct tape. Here, the Avon Animal Hospital created the largest dog ever found walking down the street. (Photograph courtesy of Henkel Consumer Adhesives, Incorporated.)

DUCT TAPE PARADE. There was a parade for the First International Duct Tape Festival held during Father's Day weekend of 2004. Here is a picture of the beginning of the parade down Detroit Road. (Photograph courtesy of Henkel Consumer Adhesives Incorporated.)